D1220593

CONTENTS

ACKNOWLEDGMENTS

I give my thanks to the individuals who first saw the value of this project and, without hesitation, stepped up to the proverbial plate with their valuable photographs and/or information to help. Thank you to D. Bradford Hunt from Roosevelt University, S. Brandi Barnes, Victoria Rowells, Alice and Nelson Scott, Sharon Warner, Beverly Ann Thompson, Priscilla Giles, Danny Reed, Erin Goseer Mitchell, Susan Cayton Woodson, Tanya Thompson, Zuri Thompson, Emmett McBain, Jonathon Romain, Thom Greene and the Edgewater Historical Society, Erick Gellman and Laura Mill from Roosevelt University, Roberta Mack, Afro-American Genealogical and Historical Society of Chicago (AAGHSC), Timuel Black, Christopher Reed, D. Bradford Hunt from Roosevelt University, Shanta Nurullah and her mother, Rosa Neal, Chicago Public Library Special Collections Department, Dominic Candeloro, Laurel Stradford, Lincoln T. Beauchamp Jr. (a.k.a. "Chicago Beau"), Dan Kelly, Diane Dinkins-Carr, Faheem Majeed and Eric Nix of the South Side Community Art Center, Sandra King, T. David Brent of University of Chicago Press, National Museum of Public Housing, the William Gottlieb Collection and Carl Van Vechten Collection of the Library of Congress, and the National Archives of Chicago. All uncredited photographs are by the author.

Although there have been many books written about the history of Chicago, a number downplay or totally ignore the role of Jean Baptiste Point DuSable, the first nonnative settler in the Chicago area. A.T. Andreas's *History of Chicago* was published in 1884, when African Americans were being virtually re-enslaved and reviled in the South. This makes it unmistakably clear at the very beginning how settlement in the Chicago area began and who started it. His book is an all too rare example of scholarship and devotion to truth trumping the "political correctness" of the times. It is too bad that many "scholars" today still ignore Andreas's example.

INTRODUCTION

The first white man around here was a black man.

The words above were interpreted from what Potowatomi Indians reportedly said about the man now known as the Chicago area's first non–Native American resident. His name was Jean Baptiste Point DuSable (sometimes spelled Pointe DeSable, Point du Sable, Pointe DuSable, or other variations), and he was, like many African Americans (our current president, for instance), a mixture of black and white (and probably other races as well).

The quote is just one of the hundreds of interesting things I learned after starting research for this book. Because, even though I'm a lifelong Chicagoan and was born at 3625 South Giles Avenue in 1947 in the heart of the area once (and now, once again) called Bronzeville, I am a little embarrassed to admit that I had almost no clue of much of the information contained here. But I would be even more chagrined if I did not believe most black Chicagoans (and 99.99 percent of white Chicagoans) are in a similar, if not the same, boat. My teachers at Wendell Phillips High— two blocks south of where I was born—never taught this history. It was definitely not in the history books then (and I would guess much of it isn't there now).

I mentioned that I had no "clue," which is a good word. One of my favorite television shows these days is *The History Detectives* on the PBS station, even though, like most Americans, I hated history in school. But now, older and hopefully wiser, I see myself as kind of a Sherlock Lowell, holding my trusty (rusty) magnifying glass to the pages of dusty tomes and reading, usually between the lines, for something closer to the truth. Maybe it is just one of the byproducts of getting older. The past becomes more important when you have less of the future.

After living long enough to see so many things, people, and places I thought were important vanish without a trace, I value my past more. So much of what I am doing here is like reattaching the dots to those fading memories.

Finding long-lost facts and torn-out, missing pages in any area of American history is difficult, and for African Americans it is even harder. But doing it for African Americans in Chicago (without the backing of a major foundation or historical institution) has been a daunting task. Those institutions, whose supposed purpose is to make this information known, seem to be better at hoarding it, keeping it only for the eyes of, in the Chicago tradition, "somebody, somebody sent."

Don't get me wrong. I am not only complaining. In the process of putting this book together, I have learned a history lesson that was not taught in school or held in any archive. Without the money and clout to access the holdings of these institutions, I had to rely on the kindness, memories, scrapbooks, and records of strangers. And I learned my greatest lesson: strangers can be very kind. Luckily, I also have kind relatives and friends.

The old song said, "Love, like youth, is wasted on the young," but you could just as easily be singing about history. That is why I think the Images of America series by Arcadia Publishing is so important and exciting. The worn-out cliché says, "A picture is worth a thousand words," but

I think it is an understatement here. Because African American images have been so historically stereotyped, debased, distorted, or ignored, the images here act as evidence of our existence as real, dignified, positive, and sentient human beings. It is hard for our children to even imagine it now, especially in the age of Oprah, but for most of our 400 years in America and well into the civil rights movement, positive images of African Americans were virtually banned from mainsteam media. If you look at a *Life* magazine from the 1940s and 1950s or watch television up until the mid-1960s, you would think the United States was Scandinavia. For a black kid who grew up at the very beginning of the television age and who loved movies, it can give you a pretty "white" idea of the world.

It was only much later, as a middle-aged man, that I found the roles John Wayne played in the matinees we watched as kids at the Louis Theater were "paled" in comparison to the African American soldiers of the Eighth Regiment Armory, which was located on the block I was born. Those soldiers actually were in the trenches and foxholes of France in World War I.

Even today, with another Big O from Chicago running the nation, the full spectrum of African American achievements in Chicago is seldom noted in the general media. And now, in the nation at large, much of our most degrading and dehumanizing entertainment is created (or at least fronted) by black folks. I say "fronted" because few (if any) of the gangsta rapping, booty-shaking, and sex-and-violence-crazed movies, videos, images, and songs are distributed by us. Tyler Perry doesn't distribute his own movies. The distribution, financing, and production are still monolithically controlled by Euro-American and Europeans. Even the idea that black consumers are the ones buying this stuff "ain't necessarily so." Experts generally agree that more white Americans and young people internationally buy hip-hop and gangsta rap than black Americans.

As a man who spent most of his adult life creating images for many of America's biggest advertising agencies and as a member of the group designated to be the official fall guys and girls of America, I think I appreciate the power of pictures even more than most. So, although much of the information here is historical, this is not a history book. I see it more like an African American family album. I have tried to include the visage of the entire family, from those of the "usual celebrated suspects" to the ones most usually ignored. The fact that I did not have the funding or backing of any big institution or historical archive actually proved to be a blessing. It forced me to go to original sources—average, everyday African Americans who value their own family histories enough to hold on to old photographs, materials, and papers. They (we) are the ultimate chroniclers of our past. We are our own historians. But, at the risk of contradicting myself, there were a few institutions and individuals within them who helped me tremendously. I have tried to list all of them in my acknowledgments, but one deserves a special shout-out: the Works Progress Administration (WPA) and their various projects, which put artists, photographers, writers, and others to work chronicling American culture in the late 1930s and early 1940s. Although it only lasted a few years, without the volume of royalty-free, public-domain images and writing I found in the Library of Congress online, this book you are holding now may not exist. At the risk of sounding partisan, this was a government "make work" project that worked.

This 128-page book cannot claim to be the full story of the incredibly deep and rich saga of African Americans in Chicago, but I have tried my best to make it a good start. So, this is just an introduction to a subject so wide and so deep that no one book, even 10 times this size, could contain it. Also, I am trying to capture a target that is still on the move.

In fact, by the time Cayton and Drake wrote *Black Metropolis*, much of it was already a memory and done in by the Great Depression. The ending of restrictive covenants was partially brought on by a lawsuit, which was echoed in *A Raisin in the Sun* by Lorraine Hansberry. Her father, Carl Hansberry, took his case all the way to the Supreme Court. By then, most middle-class, wealthy, and better-educated African Americans had started moving, ironically, farther south, out of Bronzeville, and into previously white-only neighborhoods, like South Shore, Chatham, Beverly, Pill Hill, and farther west in Englewood. Westside blacks moved into Lawndale.

Lastly, this book deals primarily with the part of black Chicago that I grew up in—the part now called Bronzeville. Who knows? If it goes well, there may be more.

One

BEFORE THE BEGINNING

Jean Baptiste Point DuSable is now the undisputed first nonnative settler in the area known as Chicago. Although experts still debate his exact date of arrival and departure, they no longer try to ignore his existence.

DuSable was only one of the many African Americans who lived in this area before the First Great Migration, which occurred largely between 1915 and 1925. Who really knows how many escaped slaves, free men and women, and undocumented peoples lived in the Chicago area before formal numbers were assembled? From DuSable's time to the 1830s, there had to have been African Americans who somehow survived and thrived in the area.

In 2006, Christopher Robert Reed, professor emeritus of history at Roosevelt University, wrote the book, *Black Chicago's First Century: 1833 to 1900*, in which he documents the rise of Chicago's black population from 77 in 1837 (four years after Chicago was incorporated as a city) to 955 in 1860, just before the Civil War. The *Encyclopedia of Chicago* says the population rose from 4,000 in 1870 to 15,000 in 1890. Reed quotes "old settlers" talking about the kidnapping of fugitive slaves with the help of local whites, even though Illinois was a supposedly free state. They also mention black Chicagoans moving to Canada after the fugitive slave laws were passed in 1850. Even though that law was seldom enforced, the city and state demanded a $2,000 security deposit for any new black person in Chicago. John Jones, a tailor who had mostly white customers, became a major political leader in those early days. And families, like the Atchinsons, Hudlins, Halls, and Wagoners, established a tradition of black leadership. Chicago's black population had grown to 40,000 by 1910. Though some scholars say the Great Migration began then, many give credit for the real onslaught to the *Chicago Defender*'s Great Northern Drive, which did not start until May 15, 1917, as America entered World War I.

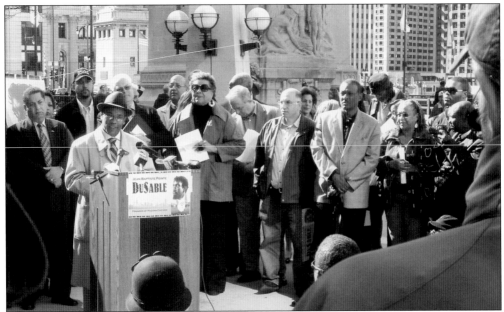

In October 2011, the 27th Ward alderman Walter Burnett spoke at the ceremony naming Chicago's Michigan Avenue Bridge as the honorary DuSable Bridge, after city founder Jean Baptiste Point DuSable (here spelled Pointe DuSable). In the photograph, he stands on the very geographical spot that DuSable built his settlement, now called Pioneer Plaza. It is located at the southern entrance to Chicago's world-renowned Magnificent Mile.

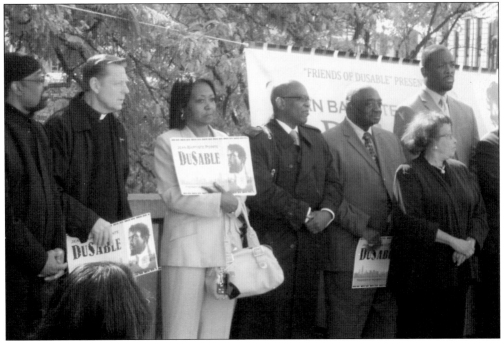

Michael Pfleger (second from left), the controversial activist Catholic priest and head of St. Sabina Catholic Church, paid his respects to his largely African American flock in Chicago's Englewood community and to DuSable by attending the dedication.

The bust of an artist's conception of DuSable standing at the northeast entrance to the bridge was erected a few years before the bridge's dedication.

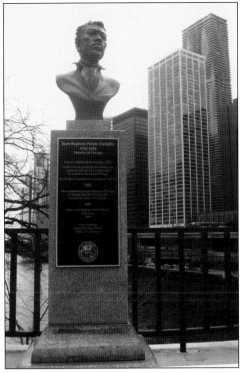

Some experts now dispute DuSable's Haitian heritage, saying he was likely the son of a white and black French Canadian couple. However, despite DuSable's disputable heritage, a Haitian American choir rehearses before they perform in the musical portion of the bridge dedication event.

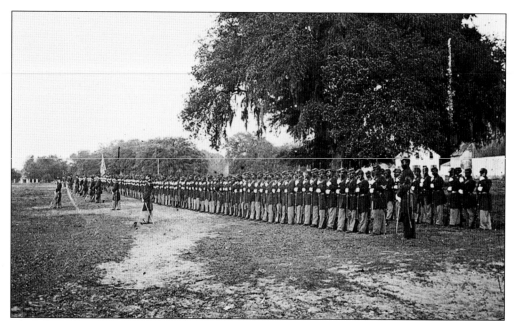

This photograph shows a formation of the newly formed US Colored Troops. There is a good chance that black men from Chicago are in the formation. (Library of Congress.)

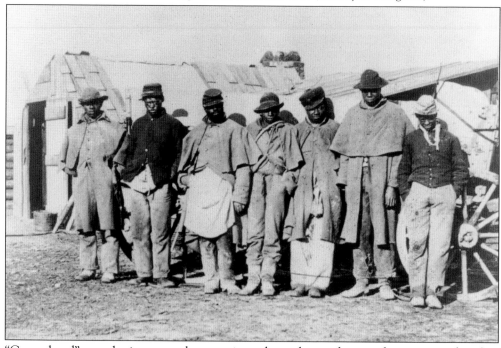

"Contraband" was the impersonal name given those slaves who somehow managed to free themselves and flee to the invading northerners. But "contraband" sure beat the even more impersonal name of "slave." Who knows . . . within a few years, these guys, dressed in the latest fashions, might have been newly minted dandified denizens who formed Chicago's Black Belt. The city's black population grew from around 600 in 1860 (before the war) to almost 3,700 by the 1870 census. (Library of Congress.)

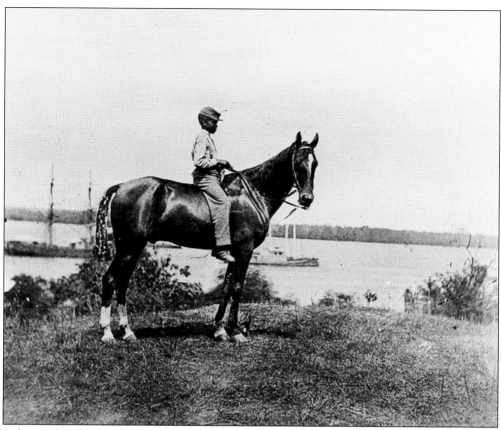

A former slave boy sits on a symbol of his new freedom after the Union army has arrived. Although Illinois was in theory a free state, the Civil War affected African Americans here greatly. Even though Chicago was considered an abolitionist stronghold, blacks faced racist, unequal treatment, still many black Chicagoans volunteered and fought. After the war, Chicago's black population grew greatly as newly freed slaves made their way North. But old Black Code laws and practices remained in place. (Both, Library of Congress.)

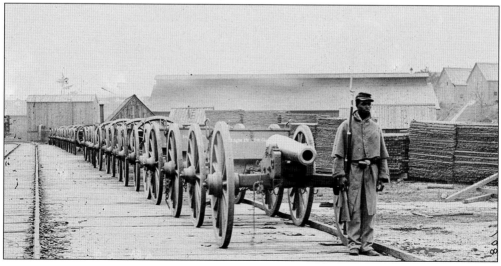

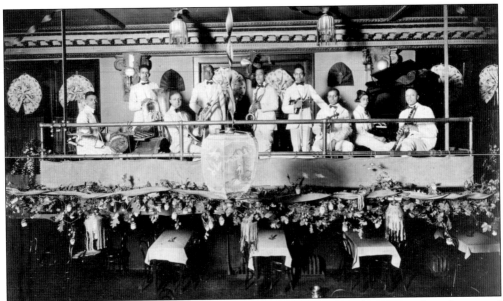

Lillian "Lil" Hardin was training as a classical musician and still in her teens when she started demonstrating sheet music at the Jones Music Store at 3409 1/2 South State Street. It was the very beginning of the Roaring Twenties. Hardin, who later became Mrs. Louis Armstrong, went on to play in many first Chicago jazz joints. She is pictured here second from right at the piano at the Dreamland Café, one of the most storied of jazz venues. (Chris Albertson.)

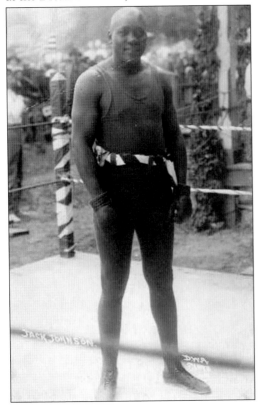

Arthur John "Jack" Johnson was born in Galveston, Texas, in 1878. But he was one of Chicago's most famous citizens when he beat "Great White Hope" Jim Jeffries to retain his title in the World Championship of Boxing in 1910. The ecstatic celebration that followed has seldom, if ever, been matched on Chicago's South Side. He had already bought a house for his mother, Tiny, at 3344 South Wabash and opened his integrated nightclub, the Café De Champion, at 41 West Thirty-first Street, which was not far from Chicago's infamous Levee district. (Library of Congress.)

The Plantation was an early Chicago club that featured some of the hot jazz of the New Orleans musicians who moved to the city. Jazz greats like King Oliver, Jelly Roll Morton, Lil Armstrong, Joe Jordon, Alberta Hunter, and Tony Jackson (the openly gay writer of the famous *Pretty Baby*) regularly played there. (Library of Congress.)

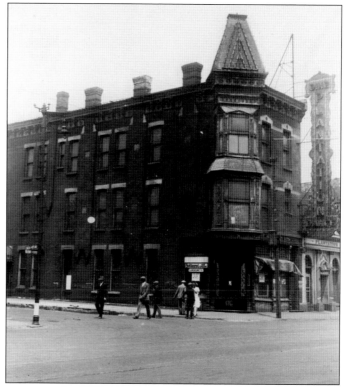

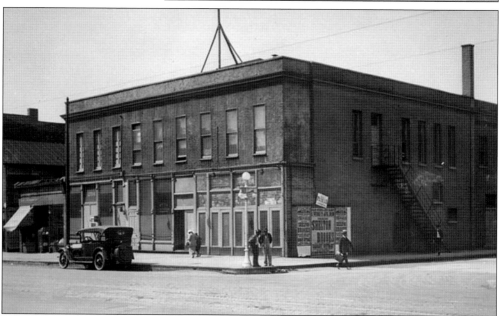

The Pekin Theater is now considered the first African American–owned stock theater in the United States. Opened by Robert Motts in 1905 at Twenty-seventh and State Streets, it was later the site of the Dearborn Homes housing project. Other now legendary venues include the Vendome, the Dreamland Café, the Sunset Café and Lincoln Gardens. The Club Delisa and the Rumboogie came much later in the 1930s and 1940s. (Chicago History Museum.)

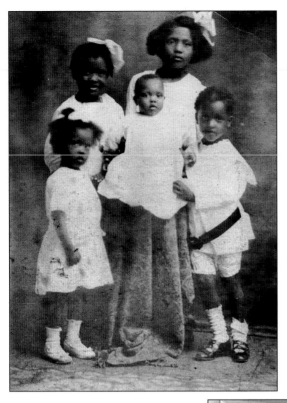

Pictured here are members of artist Alicia Lee's family. Positive, familial images showing well-dressed and attractive African Americans like these were seldom seen in mainstream newspapers and magazines at the time. Gross caricatures and stereotypes were still prevalent long after slavery ended, and it was not until the civil rights movement of the 1950s and 1960s that these practices began to change. (Alicia Lee.)

Duke Ellington first made his reputation in the cafés and music halls of New York and Washington, DC. But Duke also spent lots of time in Chicago. In fact, Chicago can be quite literally considered the home of African American musicians. The headquarters of NANMA (originally the National Association of Negro Musicians) is still here. It was founded here in 1919 by Chicago musicians, most notably the incredibly accomplished, exciting, and sometimes notorious Nora Holt. She is believed to be the first black woman to receive a master's degree in music. She went on to marry at least five times (to increasingly wealthier men) and became a noted figure of the Harlem Renaissance. (William Gottlieb Collection, Library of Congress.)

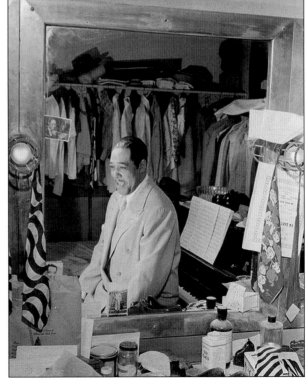

Like Euro American–owned media everywhere in the United States, Chicago's "mainstream media" made a practice of ignoring African American professionals and intellectuals in general. Black architects like Walter T. Bailey (right), John Moutoussamy, Beverly Greene, Wendell Campbell, and others did not exist in their pages. Bailey was born in 1882. He was the first African American licensed architect in Chicago. His work included the original First Church of Deliverance, which still stands at 4315 South Wabash Avenue, and the Knights of Pythias building that once stood at Thirty-seventh Place and State Street. He sometimes worked with African American structural engineers Charles Sumner Duke, another black professional largely ignored by Euro American media and history. (Both, Library of Congress.)

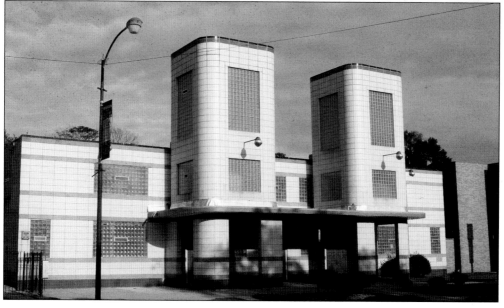

The Victory Memorial is a beautiful monument two blocks east of the Eighth Regiment Armory and is a very familiar site to Chicagoans in the mid–South Side. But only a few who walk and ride past it today know its significance to black Chicago. The base of it was originally built in 1927 to honor the "Fighting Eighth" regiment of the Illinois National Guard. A total of 137 members of the Eighth Infantry, Illinois National Guard, lost their lives in France during World War I, and they are inscribed on a bronze panel facing north. The Eighth Regiment of the Illinois National Guard became the 370th US Infantry of the 93rd Division and saw service on major World War I

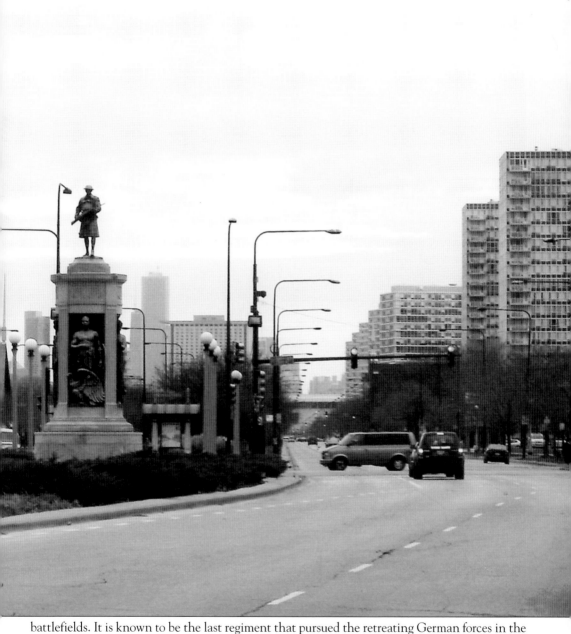

battlefields. It is known to be the last regiment that pursued the retreating German forces in the Aisne-Marne region of France before the war ended on November 11, 1918. The black doughboy on top was added in 1936. The first name in the list of dead heroes is Lt. George L. Giles. The author was born at 3625 Giles Avenue and on the same block as the Eighth Regiment Armory. After the war, Forest Avenue had been renamed to honor Lieutenant Giles.

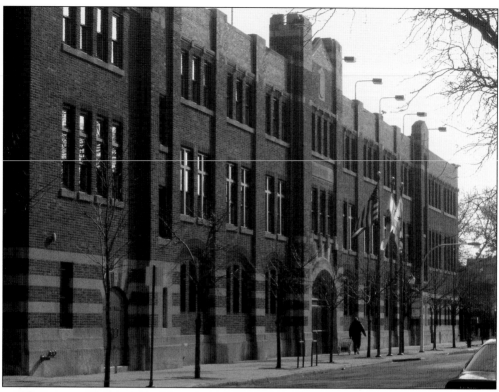

The Eighth Regiment Armory, on the southeast corner of Thirty-fifth Street and Giles Avenue, is one of the most important buildings in the history of African Americans in Chicago. Built in 1914–1915, it is the first National Guard armory in America built specifically for an African American regiment. Even the street it is on has special meaning to the story of black Chicago. Giles Avenue was named after Lt. George L. Giles, who was killed in the Argonne Forest in France in World War I. Although it sat vacant for years, it was renovated in 1999 and is now the home of Chicago Military Academy at Bronzeville, America's first public college-prep military school.

Although its original address is at 3533 South Giles Avenue, the armory was expanded north to the corner of Thirty-fifth Street when the building was renovated and repurposed in 1999.

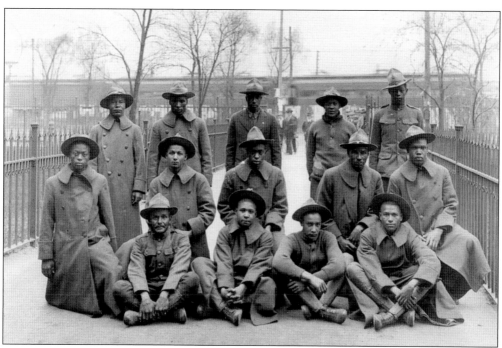

Pictured here are soldiers in uniforms similar to the ones worn by the "Fighting Eighth Regiment" in World War I. (Library of Congress.)

This plaque, near the middle of the front of the Chicago Military Academy at Bronzeville, tells the unique black Chicago story of its founding and its importance.

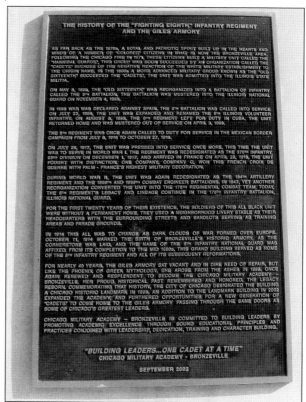

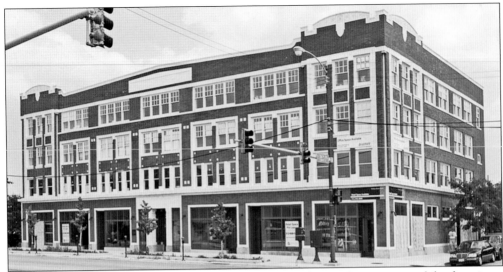

The Overton Hygienic Building at Thirty-sixth Place and State Street is one of the few pieces of evidence of black Chicago's historical achievements. Many others, like the Jordan Building a half block north, were torn down. (Photograph by Andrew Jameson.)

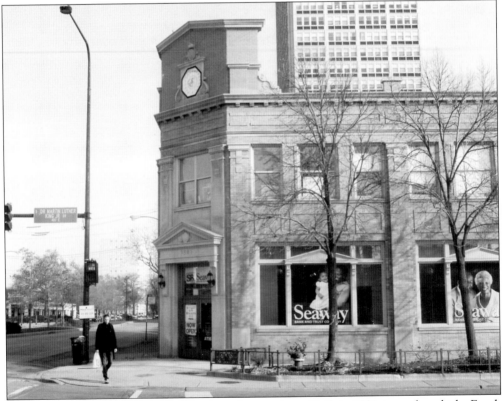

The Liberty Life Building is one of the few other survivors. Built in 1921, it was bought by Frank Gillespie when he expanded his insurance company. It became the headquarters and launching pad for a number of black Chicago's most outstanding businessmen and women as well as their careers and companies, including Earl B. Dickerson, Truman Gibson, and John H. Johnson.

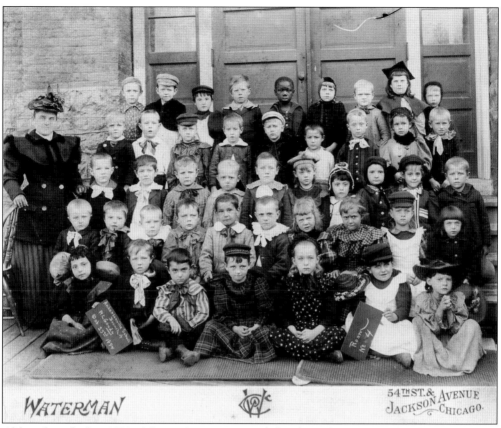

WATERMAN 54TH ST. & AVENUE JACKSON CHICAGO.

Although in the late 1890s African Americans mostly lived on Chicago's South Side, some lived in neighborhoods of other ethnic groups. The photograph above was taken in 1894 at Andersonville school. Wouldn't it be interesting to find out what happened to the little guy in the middle of the top row? (Thom Greene, Edgewater Historical Society.)

Wendell Phillips High School was the first high school in Chicago for African Americans. However, it was actually built for the children of some of the city's richest residents in 1904. But after the first Great Migration between roughly 1916 and 1920, the African American population on the South Side had grown exponentially and the pattern of white flight, which would last throughout the 20th century, had begun.

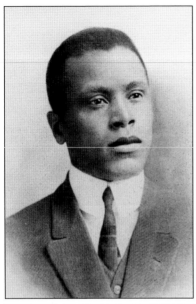

Sixty-five years before Spike Lee released his first theatrical movie in New York, Oscar Micheaux released his in Chicago. What is even more remarkable is that he did it in 1919, during the beginning of the motion-picture industry. It was a little more than 50 years after the end of slavery, and Micheaux was able to release his movie in a still overtly racist nation. (Library of Congress.)

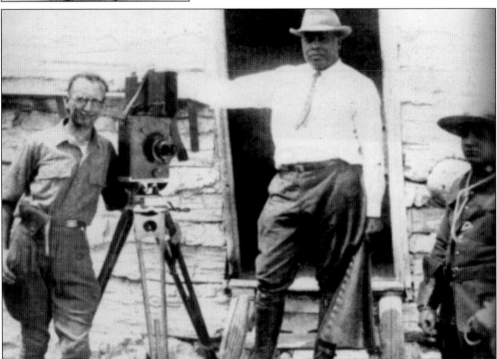

Micheaux's first film, *The Homesteader*, was made from a largely autobiographical novel Micheaux wrote about his struggles as a farmer in South Dakota while trying to maintain his marriage in Chicago. It premiered at the Eighth Regiment Armory on February 20, 1919, at Thirty-fifth Street and Forest Avenue. Before it was renamed Giles Avenue. In this photograph, Micheaux (center) directs one of his 40 movies. He had worked at jobs in other Chicago industries, including the stockyards and as a Pullman porter. This image is from an advertisement promoting his motion picture company, which was located in the heart of the burgeoning Black Metropolis at 3457 South State Street. (Library of Congress.)

Joe Jordan became a major success in Chicago, New York, and internationally. He became very profitable from performing, composing, and publishing that he built his own office building in the middle of the burgeoning Black Metropolis at Thirty-sixth and State Street in 1917, the same year that Scott Joplin died of dementia, reportedly caused by syphilis, in a New York mental hospital. (Library of Congress.)

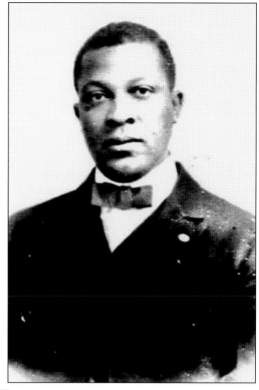

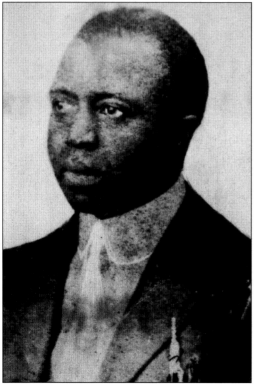

Scott Joplin first came to Chicago to show off his musical talents during the 1893 World's Columbian Exposition. He was looking to make a living playing in the "bawdy" houses, dives, cafés, and clubs along the notorious Levee Street, Chicago's red-light district that once ran from downtown to Twenty-second Street and beyond. He actually lived here briefly in 1905–1906. But while his contemporaries, like Joe Jordan, prospered, Joplin struggled to survive. He left his small apartment at 2840 Armour Avenue (the campus of Illinois Institute of Technology (IIT) sits there now), moving back to Missouri where he experienced greater success. However, he could never have dreamed his fame more than 50 years after he died when the movie, *The Sting*, made him an international star. (Public domain.)

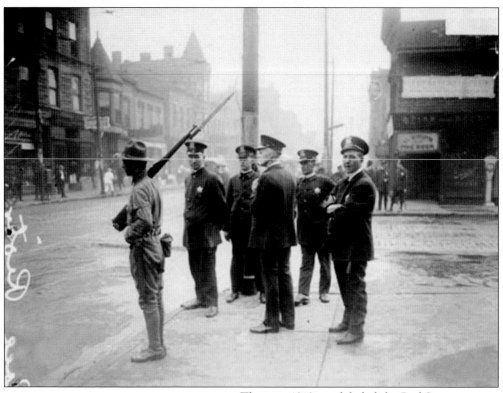

The year 1919 was labeled the Red Summer, at least in part because of the riots that occurred all over the nation. Many historians think they were caused by the refusal of African American soldiers to return to their prewar, second-class citizenship status after so many had risked and given their lives fighting for freedom in Europe. Chicago erupted on July 27, when a black teenage boy named Eugene Williams was stoned to death, presumably because he swam in "white water" near the Twenty-ninth Street beach. A member of the US National Guard stands on a South Side street corner along with Chicago policemen during the days after the riot began. (Library of Congress.)

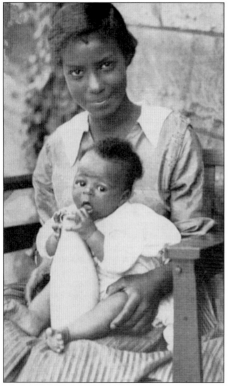

This young mother seems happy to have milk for her baby during the riot. (Library of Congress.)

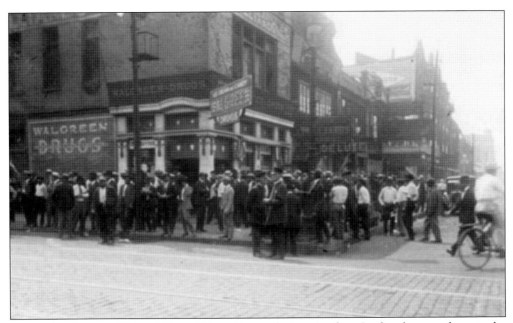

A crowd gathers on Thirty-fifth and State Streets during riot days. In the photograph, note the Walgreen Drug store. It had begun not far away on the South Side on Cottage Grove and Bowen Avenue in 1909. (Library of Congress.)

This is all that is left of the theater that stood at 108 East Thirty-fifth Street. It was originally built in 1912, when the motion-picture industry was just starting. As the Lux, it then became the Pickford, but the owners tried once again to take advantage of a popular, well-known name, calling it the Louis, after Joe Louis.

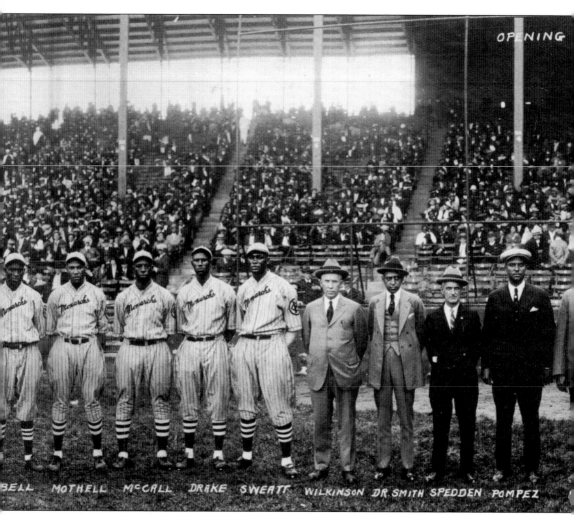

BELL MOTHELL McCALL DRAKE SWEATT WILKINSON DR. SMITH SPEDDEN POMPEZ

This amazing photograph is just a section of a panoramic image taken at the first Colored World Series. The big, black man near the middle is the person who many say was the father of black baseball, Andrew "Rube" Foster. Starting as a player, he became the brains and power behind forming the Negro Leagues when African Americans were being excluded from the all-white game. The league was so successful that it got the attention of the owners and managers of

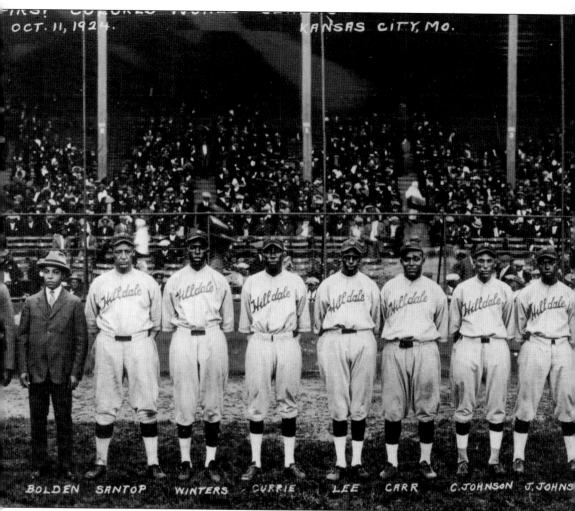

OCT. 11, 1924. KANSAS CITY, MO.

BOLDEN SANTOP WINTERS CURRIE LEE CARR C. JOHNSON J. JOHNS

white baseball leagues. The Negro League's World Series, like this one, usually sold out and was a major sporting and cultural event. But Foster's success eventually led to white baseball owners deciding they wanted to woo the best Negro League players for their league. When Branch Rickey, manager of the Brooklyn Dodgers, signed Jackie Robinson in 1947, the Negro League's days were numbered. (Library of Congress.)

They say Earl "Fatha" Hines was Chicago's Duke Ellington in the middle of the Roaring Twenties, when Chicago, not New York, was considered the jazz capital of the world. (William Gottlieb Collection, Library of Congress.)

Before Cab Calloway became one of the hippest cats in Harlem, he got his big break in Chicago. His older sister, Blanche, was already making waves as one of the few (along with Lil Armstrong) African American women heading her own band. (William Gottlieb Collection, Library of Congress.)

The story is that Billie Holiday was very angry at a Chicago club owner, who told her she "sang too slow." In response, she called him every profane insult she could think of, threw an inkwell at him, and caught the next thing smokin' back to New York. At the time, her manager was Joe Glaser, who also handled Louis Armstrong (below) and Count Basie. He told her to calm down. (Both, William Gottlieb Collection, Library of Congress.)

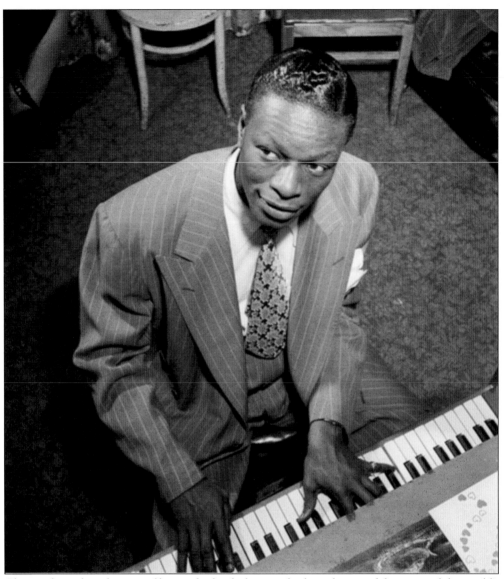

Chicago has a long history of being the birthplace or the launching pad for some of the world's greatest musicians and entertainers. Long before Chicago superstars like Kanye West were born, Nathaniel Adams Coles, professionally known as "Nat King Cole," was playing in the joints on Chicago's South Side. Cole attended New Wendell Phillips High School (which became DuSable) and became the first African American to have his own network television show in 1956. It was canceled in 1957 due to lack of sponsorship, which many believe was because of potential sponsors' fear of Southern racism and not from a lack of popularity. But Nat was only one in a pantheon of the world's brightest stars who first shone in Chicago. There were many, including Louis Armstrong, Dinah Washington, Mahalia Jackson, Earl "Fatha" Hines, Johnny Hartman, Gil Scott Heron, Sam Cooke, Curtis Mayfield, Maurice White, Howlin' Wolf, Pinetop Perkins, Big Bill Broonzy, Herbie Hancock, Kanye West, Common, R. Kelly, and Lupe Fiasco. Behind the scenes, many producers and music executives also started, or still live in Chicago, like Billy Davis, Carl Davis, Calvin Carter, Vivian Carter, Abner Ewart Jr., Paul Wilson, and Butch Stewart. (William Gottlieb Collection, Library of Congress.)

Joe Louis was in the middle of the triumvirate of world boxing champions, who made Chicago their homes for a major portion of their careers. But unlike Jack Johnson, his managers (Joe Roxborough and Julian Black) made sure he maintained a wholesome, politically correct image. (Carl Van Vechten Archives, Library of Congress.)

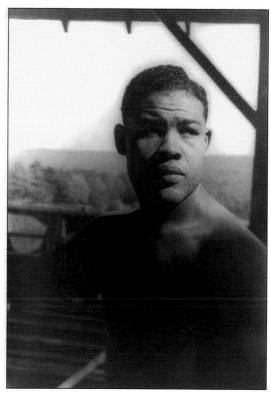

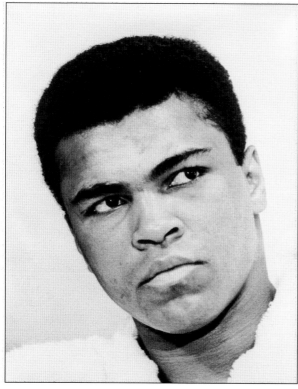

Muhammad Ali joined the Chicago-based Nation of Islam and lived on Chicago's South Side in the Woodlawn/Kenwood area for years. When combined with Jack Johnson and Joe Louis, who both lived in Chicago at the height of their fame, the proverbial "City of Big Shoulders" became the "City of the Big Black Fist." (Library of Congress.)

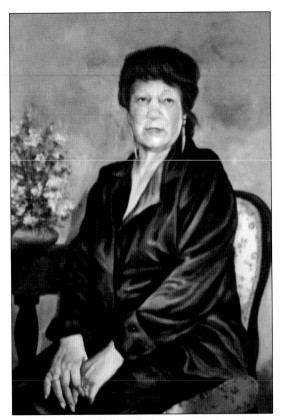

Susan Cayton Woodson (painted on the left by Jan Spivey Gilchrist) has run her gallery in her spacious Hyde Park apartment for decades. She claims an important place in not only Chicago but also the history of America. Her great grandfather, in the photograph below with her grandmother and great aunts, was Hiram Revels, the first African American senator. Woodson came to Chicago in 1940 from Seattle, Washington, chauffeured by the great actor/singer/activist Paul Robeson, a family friend. Her brother Horace Cayton also made his mark in Chicago. He coauthored with St. Clair Drake *The Black Metropolis*, one of the most important sociological studies of urban African America. (Both, Susan Cayton Woodson.)

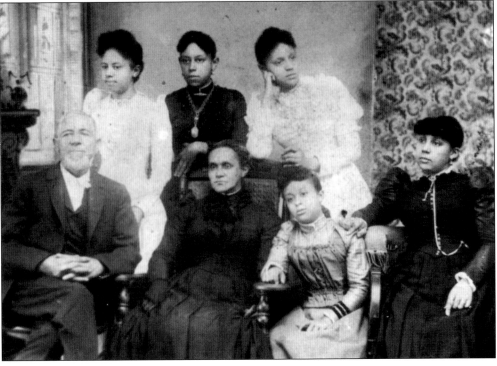

Two

GOIN' TO CHICAGO I

Experts vary on exactly when the Great Migration actually began. Some say as early as 1910, while others start around 1915. Either way, it marked a period of great growth in the African American population of Chicago, which, according the US Census figures, was around 44,000 in 1910 and had risen to about 235,000 by 1930. One big event between these dates was the World's Columbian Exposition, a world's fair in 1893 that took place on Chicago's South Side. Frederick Douglass and Ida B. Wells had come to agitate for African American participation and were met with the usual obstructions. They worked together to write a pamphlet, "Reasons Why the Colored American is Not in the World's Colombian Exposition."

But it was Robert S. Abbott and his sensational *Chicago Defender* who gets credit (or blame) for getting most black refugees from the South to see the light of Chicago's world-famous skyscrapers. He started his Northern Drive in May 14, 1917, about a month after the United States entered World War I. Chicago's meat packers, steel mills, and other companies made fortunes off the war and were looking for cheap labor to replace their Euro-American workers, who were drafted. It was also a period where Chicago capitalists were looking for ways to fight the growing call for decent wages and working conditions by the burgeoning union movement.

As with most of America's history, the confluence of money and an abundance of hungry, willing workers fueled rapid growth. On the far South Side, the Pullman Sleeping Car Company was one of the largest employers for the newly arrived Southern blacks. It was possibly the only employer in America that preferred southern Black workers because of their presumed ability to understand subservience to whites. So, it was probably quite a shock to George Pullman when (first in 1915) labor agitators, like Robert L. Mays, began to try to form a union. Ten years later, Chicagoan Milton Webster teamed up with New Yorker Asa Phillip Randolph to start the Brotherhood of Sleeping Car Porters (BSCP). Many believe this helped lead to the leadership talent and tactics that would a few decades later spark the civil rights movement of the 1950s and 1960s. E.D. Nixon, the man who brought a young minister named Martin Luther King Jr. to Montgomery, Alabama, led the 1955 bus boycott and was the head of both the BSCP and local NAACP.

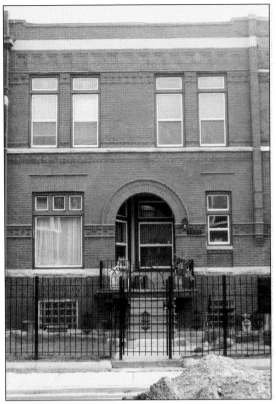

This townhome located at the 3800 block of Calumet Avenue is the address listed for Lt. George L. Giles, who was one of the members of the famed Eighth Regiment Armory about three blocks away. After World War I, this street, Forest Avenue, was renamed as Giles Avenue.

The sophisticated ladies pictured here include Brandi Barnes's aunt and friends, posing in their finest. Gloria Gardner is the short, sassy, blonde-streaked one, second from left. (S. Brandi Barnes.)

It is possible that he was dreaming of becoming mayor even back then. A 20-something-year-old Harold Washington is caught napping while on a retreat when he was a student at Roosevelt University. Washington had already served in the US Army as a sergeant by then. He enrolled in the newly formed Roosevelt College. It was one of the few that welcomed to African Americans at the time. Dedicated to President Franklin D. Roosevelt, who had died in 1945, the university had become a beacon of progressive thinking and social activism. (Roosevelt University Archives.)

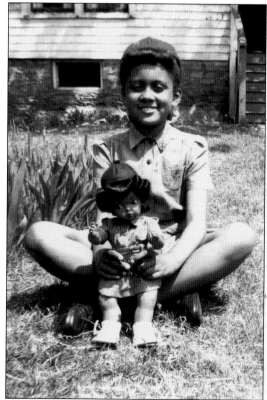

Sharon Warner is a prolific writer/poet and is now retired from her "day job" as a teacher. She is pictured here in the 1950s with Louise, her mini-me, really brown, Brownie doll. Those were the days when the very idea of a doll that was not portrayed as white was radical. But Sharon went on to break more barriers. She became one of the first and few African Americans hired to create television, radio, and print advertisements for America's leading agencies, starting at Chicago's largest advertising agency, Leo Burnett, in 1969. (Lillian Warner.)

Kings: The True Story of Chicago's Policy Kings and Numbers Racketeers by Nathan Thompson was a book published in 2000s that chronicles the almost unbelievable story of black Chicago's policy kings. "Policy" was the name used for the number-based gambling craze, which some say was started in Chicago's Levee area in the late 1890s by an African American called Policy Sam. By the mid-1920s, it had become a major moneymaking force on Chicago's South Side. Thompson (not related to author) did monumental research in bringing back to life this colorful history.

By the 1980s, black Chicago had grown to roughly 40 percent of the population. The time was ripe for something that had been the most imaginative dreamers' dreams—a black mayor. But why was this not possible? The whole era of African American mayors had begun a borderline away in Gary, Indiana, almost 30 years before. Here, Harold Washington is campaigning in Uptown before the 1983 election and is pictured with John Taylor and Meg Collins's daughter Bridgid. (John Taylor and Meg Collins.)

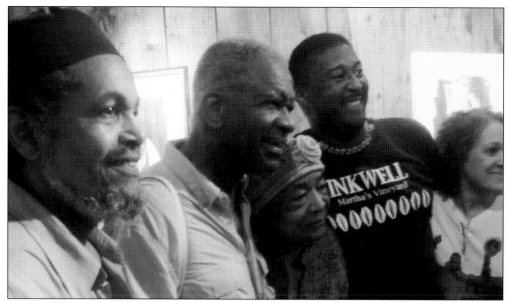

Napoleon Jones-Henderson, far left, joins internationally acclaimed artist/sculptor Richard Hunt (second from left) as he hugs professor/writer Dr. Samella Lewis (and two admirers) at her book signing at the South Side Community Art Center (SSCA). Lewis was presenting her massive tome on another artist with ties to Chicago and the SSCA, Richmond Barthé, who went on to participate in the Harlem Renaissance and later became a favorite of Hollywood when he moved to California.

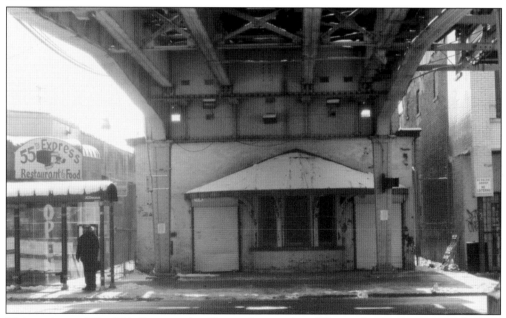

This station at Fifty-fifth Street under Chicago's green line "L" is said to be the first one built in the city's elevated track system. Originally, it serviced the massive crowds attending the famous 400-year anniversary of Columbus's discovery of America. The World's Columbian Exposition attracted visitors worldwide. But Frederick Douglass and Ida B. Wells came to protest the exclusion of African Americans from its exhibitors and their segregation as attendees.

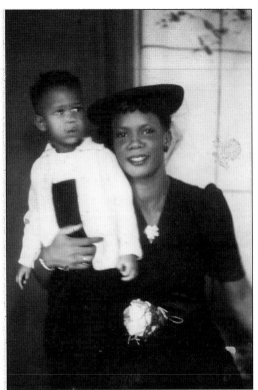

This c. 1940 photograph shows a pretty, young mother with her child. It is another one of the images the Scotts retrieved from discarded memories of many anonymous Chicago families. (Alice and Nelson Scott.)

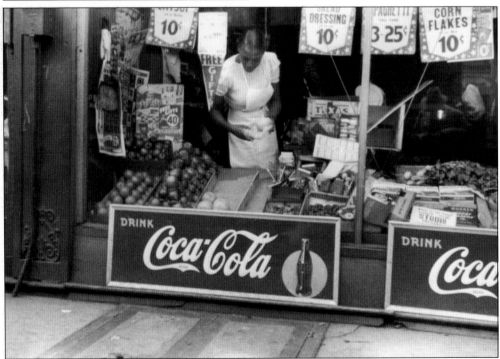

Pictured here is a grocery store on the South Side. The 10¢ cornflakes show how long ago this photograph was taken. (Library of Congress.)

Nelson and Alice Scott have been collecting African and African American art for many years. Their Hyde Park home is filled with original images and artifacts reflecting their pride in their heritage and culture, which are almost all created by black artists. Nelson is also an avid collector of photographs and memorabilia related to our history. Some of the photographs in this book were rescued by him from the city's junk shops and scrap heaps.

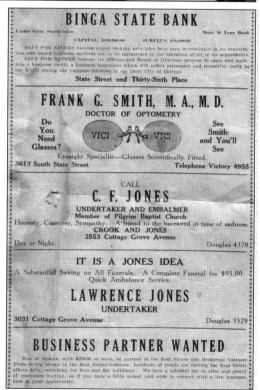

These advertisements came from a Pilgrim Baptist Church newsletter in 1923. The top advertisement is particularly important. The Binga Bank was the first black-owned state bank in America. (S. Brandi Barnes)

Margaret Burroughs and husband, Charles Burroughs, lived in this mini-mansion in the 3800 block of South Michigan Avenue for years. It was one of many "fixer-uppers" left abandoned or turned into multifamily tenements when wealthy whites fled during the expansion of the Black Belt. In the 1960s, they turned a portion of it into the first home of Chicago's famous DuSable Museum.

Margaret Burroughs died at age 95 in November 2010. Up until her last few months, she remained active. Here, she leaves the Lake Meadows Art Fair, one of her creations, for the last time, in 2010. A memorial service was held for her at the museum she and her husband founded in their home in 1961.

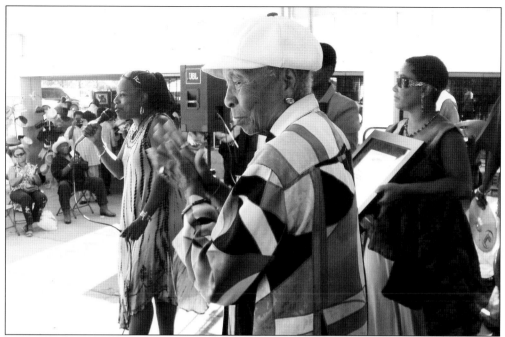

Margaret Burroughs's family came to Chicago from Louisiana when she was a child. She was one of the original founders of the South Side Community Art Center, along with many other cultural institutions in Chicago and throughout America, including the Lake Meadows Art Fair, the National Association of Black Artists, and the DuSable Museum. She is pictured here (center) in 2010, along with Helen West (left) and Deborah Crable (right) at the Lake Meadows Art Fair.

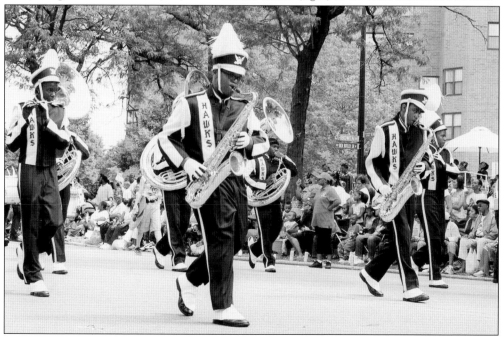

The Bud Billiken Day Parade has been a part of black Chicago for over 80 years. It was started as a kid's promotion by the *Chicago Defender*. (Photograph by Curtis James Morrow.)

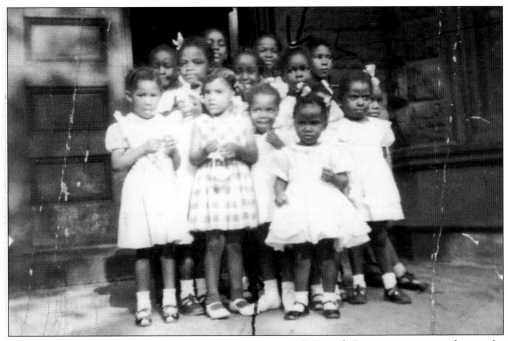

S. Brandi Barnes, a writer and retired schoolteacher, contributed these beautiful images of her family, which were taken in 1929. Her grandmother first moved to Chicago from Atlanta, Georgia, in the 1920s. Brandi is pictured above with some friends at a 1952 birthday party. Below, she is in her cap and gown at a graduation ceremony at Pilgrim Baptist Church. (Both, S. Brandi Barnes.)

On the left, S. Brand Barnes is pictured with her grandson Brandon. On the right, Brandi's grandmother (sitting) is flanked by her daughter and Brandi's father, who was six years old. (Both, S. Brandi Barnes.)

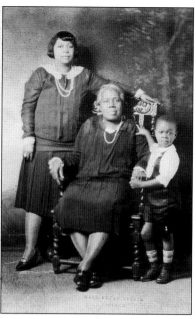

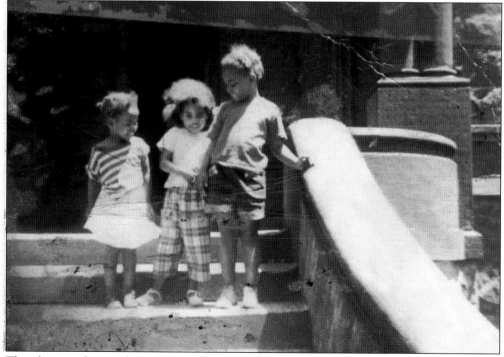

This photograph was taken on East Forty-seventh Street in Bronzeville. S. Brandi Barnes says this was when she, her sister Linda (left), and friend Donna (middle) managed to evade her mother's hairbrush before going out to bask in the morning sun. (S. Brandi Barnes.)

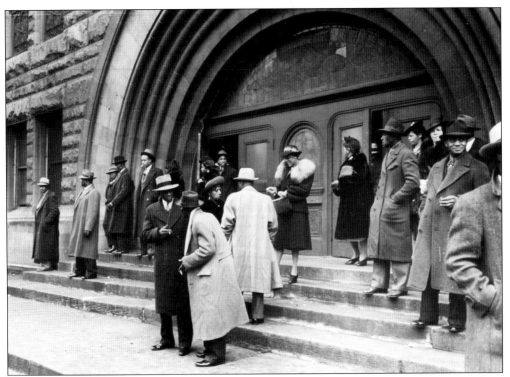

Pilgrim Baptist Church was one of the most influential African American organizations from the 1920s and onward. On Sundays, black Chicagoans of much economic and social status came together for religious services, social and political contacts, and displays of wealth and power, even if they could only pull it off on Sunday. Unfortunately, in 2006, a fire devastated most of the building. (Library of Congress.)

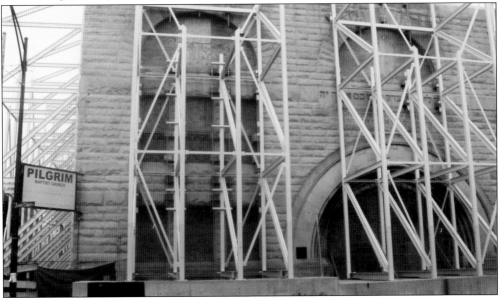

Only the outer facade and two sidewalls still stand today. But the iconic archway is still as visible as it was in 1941.

Three

GOIN' TO CHICAGO II

According to Nicholas Lemann's book *The Promised Land*, the Second Great Migration dwarfed the first. From 1940 to 1960, sociologists say the African American population in the city grew from about 278,000 to over 800,000. By then, even though it was a smaller total than New York's black population, it comprised a larger portion of the city's total and was more politically and culturally monolithic and powerful. The South Side of Chicago was considered by many experts to be the black capital of America. This time, unlike the first migration, the propaganda efforts of the *Chicago Defender* played almost no direct role. Lemann says this monumental move was spurred in the mid-1940s because of the perfection of a production-ready machine, which could pick exponentially more cotton than a human. The work for sharecroppers vanished almost overnight.

But the new migrants faced a much less welcoming city. Chicago's famous stockyards had steadily declined in the 1950s and 1960s and closed in 1971. The Pullman Palace Car Company and thus Pullman Porters were history by the mid-1950s, and even though the American economy was still relatively vibrant, it had begun to plateau. By then, even the massive steel mills of South Chicago and Gary, Indiana, were in decline. By the mid-1970s, America's postwar economic boom was just about done. Even undereducated white Americans were beginning to lose their relatively high-paying, blue-collar jobs to international competition. Typically last hired, many first-fired African Americans would now not be hired in the first place.

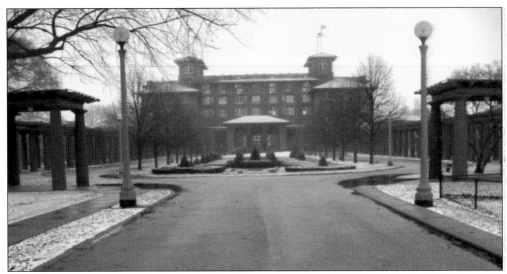

This magnificent building was about to meet the wrecker's ball in the mid-1970s when a grassroots group, including community activists Harold Lucas and Raynard Hall, initiated a campaign to save it for the South Shore community. Built in 1906 as an exclusive private country club that proudly excluded Jews and African Americans, it was then rebuilt and expanded in 1915. It is now one of the brightest jewels in the Chicago Park District's cultural crown and houses the South Shore Cultural Center. Below, the interior looks like something out of *The Great Gatsby*. It has been recently refurbished and now hosts a restaurant, a theater, and many beautiful, spacious rooms for dance, art, music, and literary events.

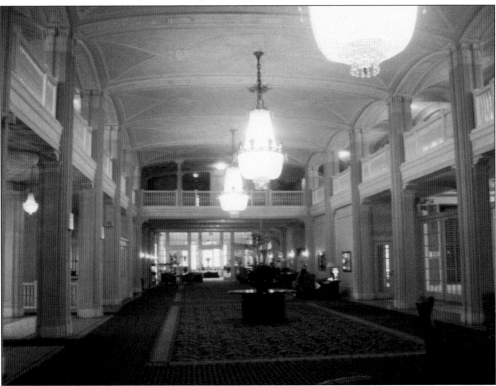

This poster is commemorating First Lady Eleanor Roosevelt's dedication of the South Side Community Art Center in 1941. Although only one of hundreds of centers that opened near the end of the Great Depression, it is now said to be the only one still operating. This was only possible because African American art and culture lovers continued to support the center, even when the federal, city, and state governments withdrew their support within two years of the opening. (South Side Community Art Center.)

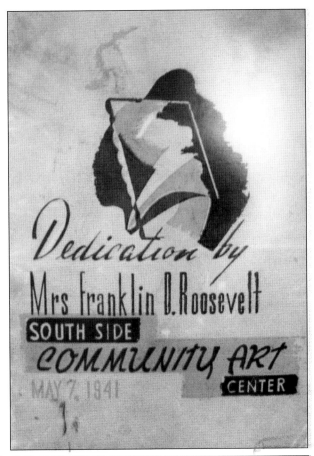

The Nation of Islam (a.k.a. "the Black Muslims") started in Detroit in 1930, but Elijah Muhammad moved its headquarters to Chicago within the decade. It purchased Mosque Maryam, Temple No. Two at 7351 South Stony Island Avenue in 1972.

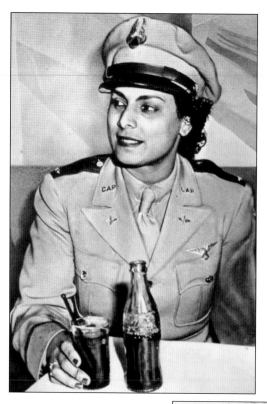

The amazing, beautiful Chicagoan Willa Beatrice Brown became the first African American woman to receive a commission as a lieutenant in the US Civil Air Patrol. During World War II, she served her country by training pilots for the US Air Force. Before the war, she followed in the footsteps of another African American Chicago woman, Bessie Coleman, who led the path. Brown then helped to lead the flight school that Cornelius Coffey founded in Chicago in the late 30s. It is said to be the first African American owned and operated aeronautics school in the United States. She also went on to help train the famed Tuskegee Airmen. A major movie, financially backed and directed by *Star Wars* creator George Lucas, is scheduled to be released just before Black History Month in February 2012. (National Archives.)

This photograph shows Col. John Robinson returning from his excursion to Ethiopia, after he helped their air force defend themselves against Mussolini's Italy. He was known by them as "The Brown Eagle." Robinson and his fellow mechanic friend, Cornelius Coffey were, at first, refused admission to Curtis Wright School of Aviation because of their color. But many say that when their white employer, Emil Mack, threatened to sue, the school backed down and admitted them. Both graduated at the top of their class. (National Archives.)

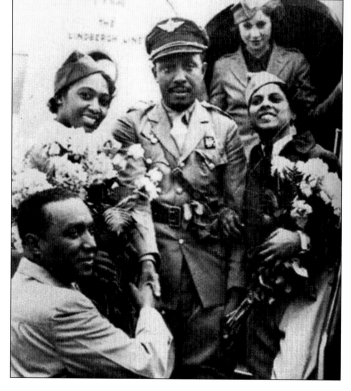

Alicia Lee (pictured) is an artist and, with her sister Evelyn and daughter Aisha, a member of a belly dancer troop. She is also an art instructor for the Chicago Park District. (Alicia Lee.)

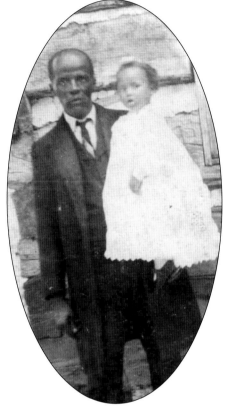

Alicia's aunt Inez, now in her nineties, is the little girl in the arms of her father, whom Alicia knew as Papa Buck. (Alicia Lee.)

My, my, how little Inez has grown. By then a dancer, an always-outgoing Inez gave the brave brothers overseas in World War II a reason to get the war over with soon. (Alicia Lee.)

In this photograph from around the 1960s, Lil Armstrong stands with Louis's old trumpet outside their house on East Forty-first Street, where she lived long after she and Louie divorced. (Chris Albertson.)

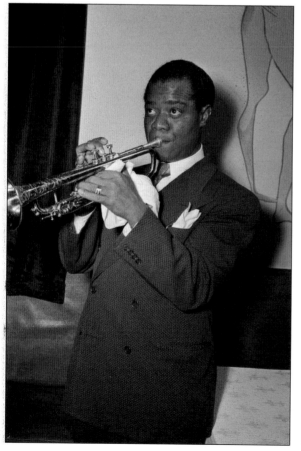

By the time Louis Armstrong (left) met the lady above in Chicago, she was already a musical star. Lil Hardin played piano in some of the city's hottest clubs. She helped to "hip" him to the big city and eventually became his second wife. Legend has it that it was Hardin who helped make Louie the superstar he became by talking him out of being second banana/cornet in his mentor King Oliver's band. He also played in her band. In 1925, Hardin, Louie, and three others recorded the first in a series of "Hot Five" sessions in Chicago. It's now considered by many to be the most influential jazz records ever made. (William Gottlieb Collection, Library of Congress.)

The tall, dark, and handsome gentleman strolling with this lovely lady was a graduate student at the University of Chicago. Many who know about the history of African American education will no doubt recognize him as the young Dr. Benjamin Mays, who would go on to become the president of Morehouse College in Atlanta and the intellectual mentor to many of our nation's greatest leaders, including Dr. Martin Luther King Jr. This image was in the collection the grandmother of S. Brandi Barnes, Alma L. Stewart, who was head cook at one of the University of Chicago dining commons. (Alma L. Stewart.)

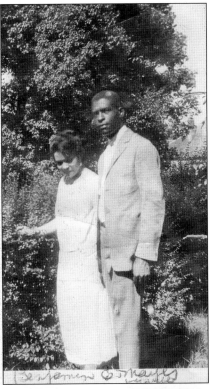

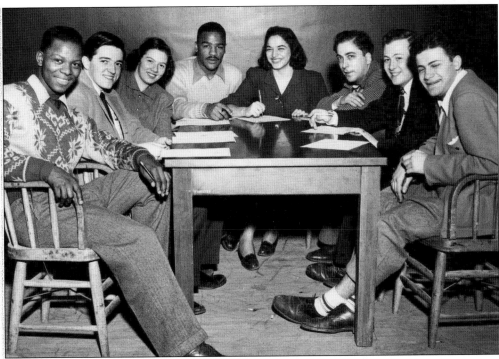

A young Harold Washington is the man in the center of this photograph of a student group meeting at Roosevelt College in the late 1940s or early 1950s. (Roosevelt University Archives.)

On the south and west sides, there are acres and acres of empty land where African American homes stood. Here, at Fifty-sixth and State Streets, is a symbol of the syndrome and the system that created it. African Americans first moved here when Euro-Americans fled the second Great Migration in the 1940s, 1950s, and 1960s. Apartments originally built for one family were cut into

54

smaller units for larger families—at higher rent. They called them "kitchenettes." Then, when the black community threatened to spread out even farther, the high-rise jungles known as housing projects were built to warehouse them. When the housing projects began to crumble 40 years later, they were torn down amid promises of a new start for their poor black and former tenants.

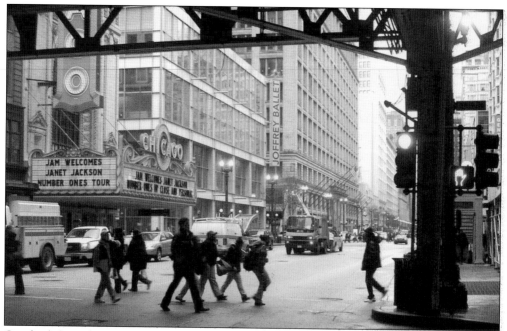

On the left in this recent photograph of the corner of State and Lake Streets in downtown Chicago is the world-famous Chicago Theater, built by the Balaban & Katz movie-house chain in the 1920s. Janet Jackson, a younger offspring of the famous family from Gary, Indiana, is on the marquee. Another B&K movie palace, the Regal, was the first big venue where her older brothers, the Jackson Five, showed their stuff.

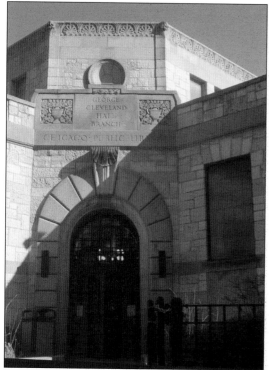

The George Cleveland Hall Branch of the Chicago Public Library was the city's first public library in the black community. Vivian Harsh became Chicago's first African American branch head here in 1932. It has been a gathering place and resource for black Chicago intellectuals for many years. It was named after one of the civic leaders and one of the original Chicago NAACP members. Located on the corner of Forty-eighth Street and Michigan Avenue, renowned figures, like Langston Hughes, Richard Wright, Gwendolyn Brooks, and Margaret Walker, once used it as a refuge from the hard realities of the South Side streets.

Dale Washington (above) was once one of Chicago's most prolific artists. And though he moved toward the West Coast recently, during his time in Chi-Town he left an indelible mark as both an artist and a force for African American creative culture. His open houses and dinners became popular for hungry artists and collectors alike. From about 2000 to 2010, Dale hosted illustrious guests, authors, collectors (like Dan Parker and Patric McCoy), and many others, including those pictured below at his home/studio near Seventieth and Paxton Avenue in South Shore. Sam Greenlee (second from left) is the author of one of the most controversial books of the late 1960s, *The Spook Who Sat by the Door*. Here, he reads from one of his recent poems, and Rachelle Johnson, a writer and poet, admires his artistry. (Photograph by Charles Bonilla.)

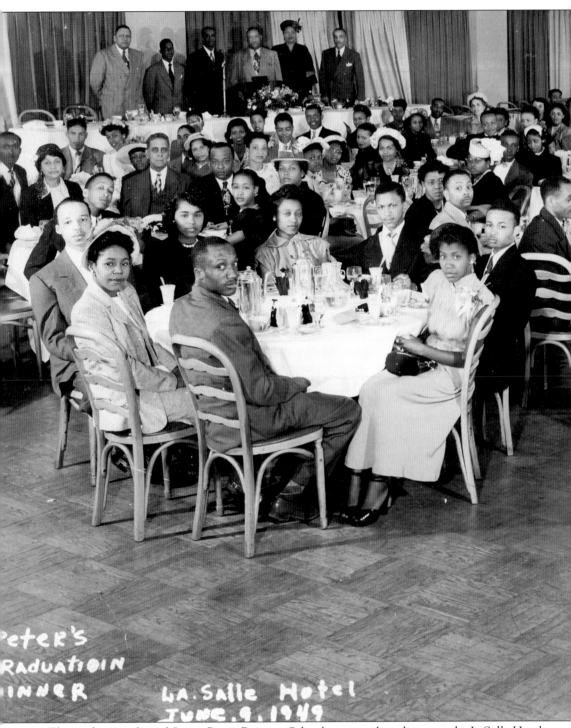

The graduating class of Cortez Peters Business School poses at their dinner at the LaSalle Hotel in downtown Chicago on June 9, 1949. The photograph represents a side of black Chicago life that was seldom seen in mainstream media, which mostly covered sensational news of murders and mayhem. Long before personal computers, the Internet, and businesses like Google, Apple,

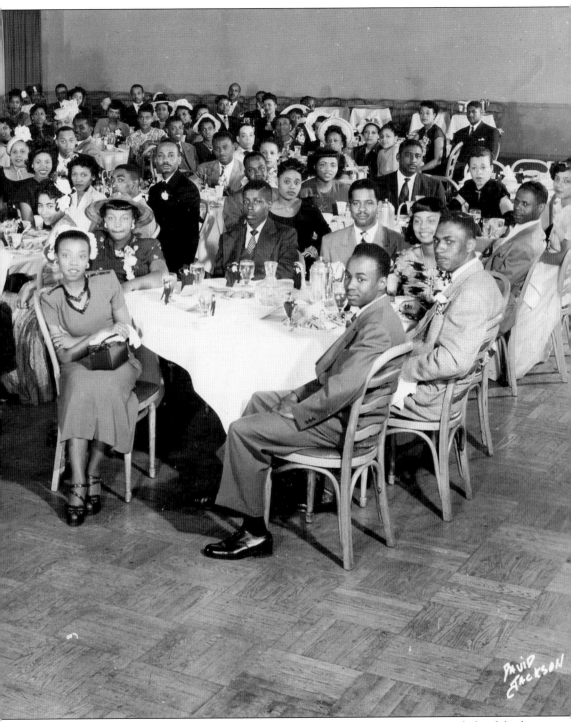

and Facebook were ever imagined, Cortez Peters, an African American typing wunderkind, built a business that trained black Americans how to succeed in the still highly segregated and racially restricted corporate world of America. Alicia Lee's aunt Inez is somewhere in this photograph. (Alicia Lee.)

Tuskegee Airman Dr. Welton Taylor, 92, is pictured here in March 2011 at a meeting of the African American Genealogical and Historical Society of Chicago. He claims kinship with Zachary Taylor, the president of the United States. During World War II, he was flying a mission when his plane crashed and wound up walking miles through dense jungle to escape enemy territory. He is now working on his memoirs with Timuel Black, also 92, the Chicago teacher/historian and civil rights activist.

Robert A. "Bobby" Sengstacke made his name in the field of photojournalism and documentaries. His images of African and African American life from the beginning of the civil rights era until now are iconic. Here, he takes a shot with a pocket digital camera at the Sixth Annual Lake Meadows Art Fair in June 2010.

Members of the Afro-American Genealogical and Historical Society of Chicago (AAGHSC) prepared to present their 30th Anniversary Heritage Book at their March 2011 meeting. The 9-inches-by-11-inches hardcover is 386 pages long. It contains an amazing compilation of stories, pedigree charts, family group sheets, and photographs, many supplied by AAGHSC members. Janis Minor-Forté (far right) spearheaded the monumental, two-year effort.

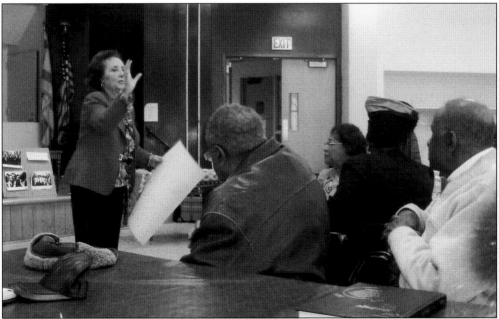

Later in the meeting, Erin Gosseer Mitchell shows a newspaper article related to her new book, *Born Colored*, to members of AAGHSC. Mitchell was born in Selma, Alabama, before the civil rights era. Her book chronicles the life her family was forced to live, and how it led to many culminating events, like the famous march across the Edmund Pettus Bridge by Dr. Martin Luther King Jr. and civil-rights activists in 1960s.

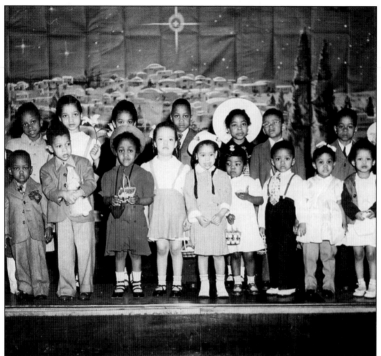

Rosa Neal, whose family first came to Chicago in the early 1900s, sent this photograph of youthful members in the Hartzell's Easter pageant. (Rosa Neal.)

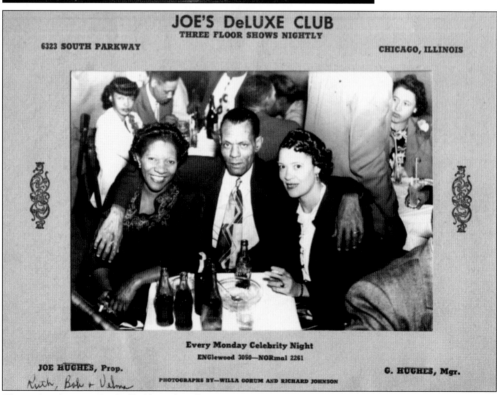

Shanta's relatives Ruth (left) and Robert Howze paint Chi-Town with Aunt Velma here in a classic Chicago nightclub photograph. (Rosa Neal.)

Wallace Neal does the honors of cutting the cake at his birthday party. His little sister Velma (now Shanta), left, sits patiently waiting for her cut. The stern fellow with his arms firmly folded is obviously is going to cause trouble if Shanta tries to grab the first piece. (Rosa Neal.)

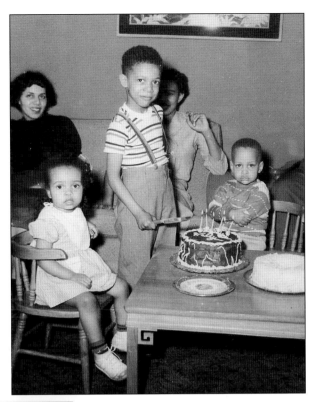

Velma Patrice Neal (who legally changed to her stage name to Shanta Nurullah in 1973) still performs with her musical group and is a professional storyteller, indulging her love of literature and culture as a bookseller. She says her mother's side of the family came to Chicago in 1924 from Meridian and Moss Point, Mississippi. Her father's side came to escape the racist, deadly riots of 1921 in Tulsa, Oklahoma. (Rosa Neal.)

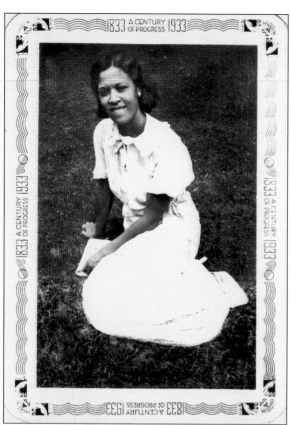

Shanta's mother, Rosa Lee Campbell, is pictured here in 1933. (Rosa Neal.)

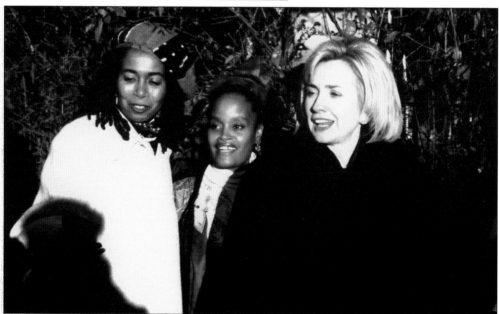

Shanta Nurullah (left) and her group Samana performed for then first lady Hillary Rodham Clinton (right) in a Chicago park near Eighteenth & Prairie Avenue, on her 50th birthday. That's group member Aquilla Sedulla standing in the middle. (Shanta Nurullah.)

Pictured here is international bluesman, writer, and publisher, "Chicago Beau," performed in Finland in 2011. Born as Lincoln T. Beauchamp Jr. in 1949, he remembers growing up on the South Side when his father had his law office in the South Center complex, which was built as part of the Regal Theater/Savoy Ballroom development in 1927. "My father worked with lots of entertainers when Forty-seventh Street was 47TH STREET. But he also handled labor unions, civil rights folks [before there was a civil rights movement]. By the time I was old enough to understand what we had then, it was almost gone." Beauchamp Sr. came to Chicago from Henderson, Texas, in 1926 at the very beginning of what was called "the Black Metropolis" and continued working well past its height. (Both, Lincoln Beauchamp Jr.)

Chicago Tribune, Saturday, November 16, 1996 Section 1 19

OBITUARIES

Lincoln T. Beauchamp Sr., 92, pioneering South Side attorney

By Kenan Heise
TRIBUNE STAFF WRITER

Lincoln T. Beauchamp Sr., 92, an attorney who practiced in the African-American community on the South Side of Chicago for more than 50 years, handled almost 15,000 cases, according to the casebook he kept from 1940 until several months ago.

A resident of the South Shore neighborhood, he died Tuesday in the West Side Veterans Hospital.

His office had for several decades been at 417 E. 47th St.

"In those days that was a thriving community, one in which his clients were black professionals, musicians and others," his son, Lincoln Jr., said. "He also represented many young blacks, many of whom were involved in the injustice of the criminal court system that found them guilty by complexion, because of their color. He never retired. The last entry in his casebook was in July."

Mr. Beauchamp, a native of Henderson, Texas, had moved to Chicago in 1926 after traveling throughout the country.

"It was his boyhood dream to become a lawyer," his son said. "He wanted to be one, as he liked to put it, 'in order to circumvent the system of injustice' he had personally experienced."

He was able to enter John Marshall Law School in the late 1920s because the dean there was from a family that had long been active in behalf of blacks, including having operated a station on the Underground Railroad for slaves fleeing the South before the Civil War. Mr. Beauchamp kept detailed records of his schooling at John Marshall, where he was the only African-American in his classes. They show him paying $10 a month for tuition and contain a copy of his hand-written

Lincoln T. Beauchamp Sr.

legal thesis.

From the time of his graduation in 1932 until he was able to open an office in 1940, he worked as a clerk in a warehouse.

Survivors, besides his son, include a daughter, Margaret; a sister; and three grandchildren.

Services were held in Chicago.

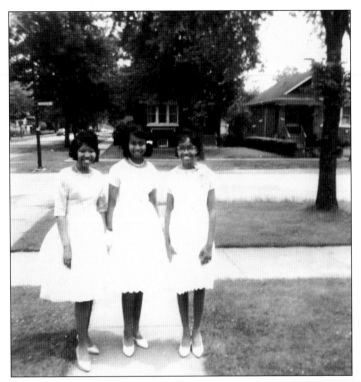

Shanta Neal (center) and two girlfriends are pictured outside of her home on Chicago's South Side around the 1960s. Photograph like this, which showed middle-class African Americans and their well-kept neighborhoods, were seldom seen in the mainstream media, helping perpetuate the image of black poverty, dysfunction, and dependence. Newspapers like the *Chicago Defender* and *Ebony*, a Chicago-based magazine, were two of the few places where positive, healthy, and educated African Americans could see themselves. (Rosa Neal.)

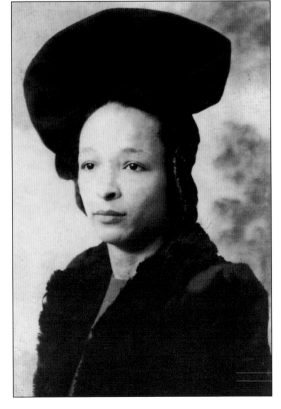

This photograph shows a well-dressed, sophisticated-looking African American woman, and it is another image seldom seen in white-owned media until after the societal changes brought on by the civil rights movement. Even today, the vestiges of America's racist past can be seen in most mainstream media. One of the major changes is the over-coverage of a handful of black celebrities. (Alice and Nelson Scott.)

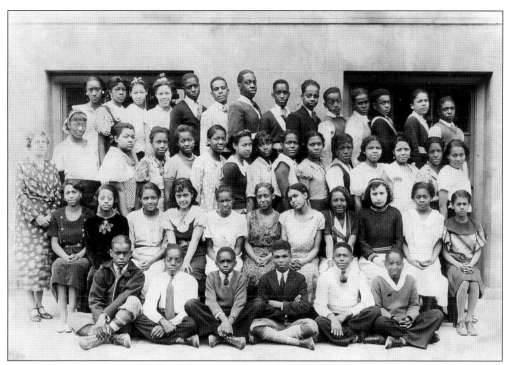

Pictured here is a class at Willard Elementary School, when young men and women still tried to dress their best. (Rosa Neal.)

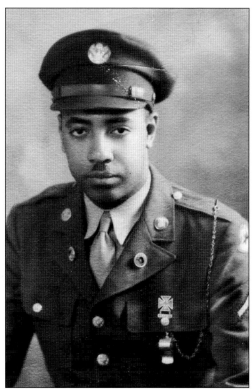

Wallace Neal, Rosa Neal's husband-to-be, is pictured here in uniform while serving in the US Army during World War II. Images of black soldiers and sailors were habitually left out of general publications in America, even though they served in every war since the Revolutionary War in 1776. Many scholars today see this as another attempt to deny black claims to equal treatment, justice, and civil rights. No matter how many brave men and women risked and gave their lives defending the United States over the course of its history, African Americans are still fighting a war for equality at home. (Rosa Neal.)

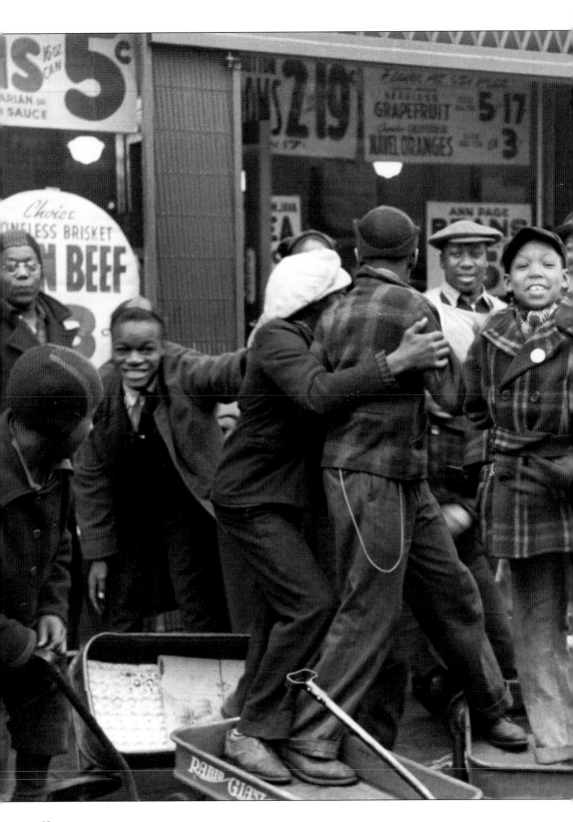

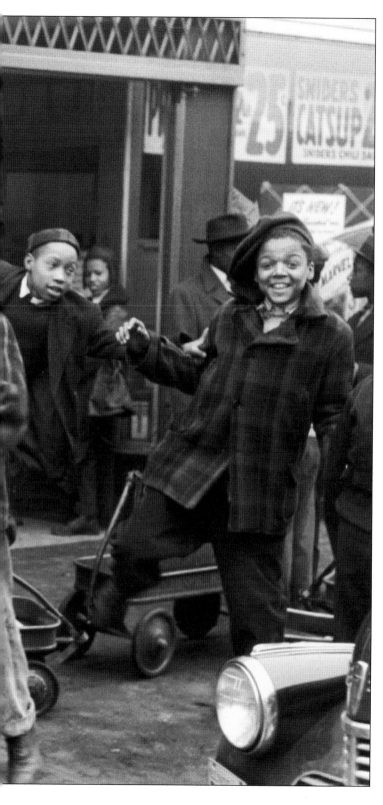

This is another great photograph taken in the early 1940s by the seemingly ubiquitous photojournalist Russell Lee, when he was documenting South Side's part of the WPA Farm Security Administration project. Gordon Parks also got a job working for the WPA. Parks went on to be the first African American photographer hired by *Life* magazine and became the groundbreaking director of movies like *Shaft* and *The Learning Tree*. But the WPA did not just employ photographers. Its workers built many of the public libraries we use today. There is a current debate about the value of "make-work" projects like those created by Franklin Roosevelt during the Great Depression, but many of the things we use today—like this photograph—would not exist without the WPA project. (Library of Congress.)

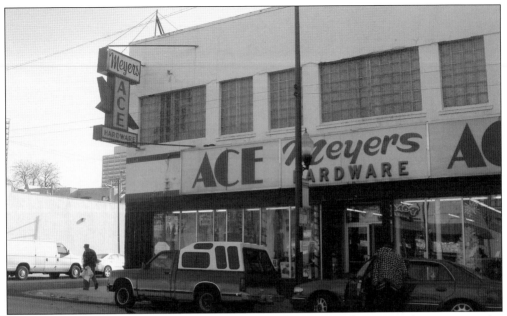

This Ace Hardware store is probably one of the few that gets regular visitors from tourists who come from all over the world. The corner of Thirty-fifth Street and Calumet Avenue was not always Ace Hardware. It was once the home of two of Chicago's hottest jazz venues, the Sunset Café and the Grand Terrace. In the 1920s and 1930s, it was where King Oliver, Lil Hardin, Blanche Calloway, Jelly Roll Morton, Joe Jordan, and others helped create the music known as jazz.

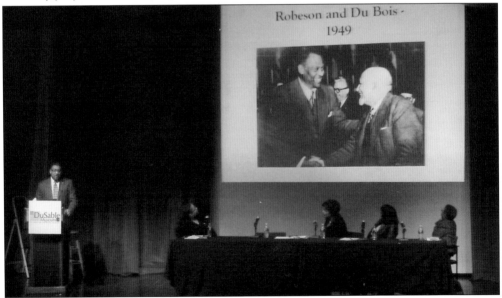

A historic event at the DuSable Museum in early 2011 happened when the living relatives of four of African America's most notable figures came together to honor their distinguished ancestors. Here, the grandson of W.E.B. Du Bois presents a slide of his grandfather with another great black figure, Paul Robeson. Sitting and watching, from left to right, are moderator Charlene Drew Jarvis, daughter of Dr. Charles Drew; Michelle Duster, great-granddaughter of Ida B. Wells; and A'Lelia Bundles, great-great-granddaughter of Madam C.J. Walker.

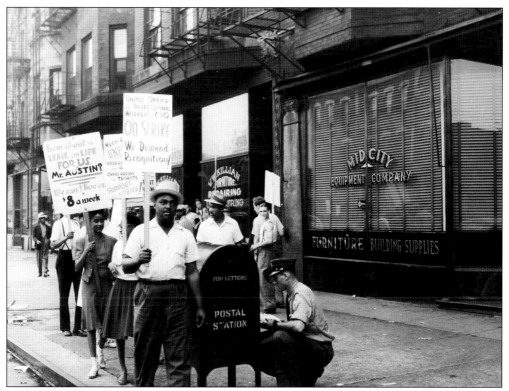

The civil rights movement is associated with the late 1950s and 1960s, but Chicago's African Americans are seen here demonstrating in the early 1940s. In fact, James Farmer helped found the Congress of Racial Equality (CORE) in Chicago before going south in the 1960s to join Dr. Martin Luther King Jr. and other civil rights activists of all colors to continue the push for equality and justice—for all. (Library of Congress.)

The original home of the *Chicago Defender* from 1920 through 1960 still stands at 3435 South Indiana Avenue. It is now a part of the historic district called the Black Metropolis. Harold Lucas, of the Bronzeville Visitors Center, fought for years to preserve this and other vestiges of black Chicago's fast disappearing past. (Photograph by Antonio Vernon.)

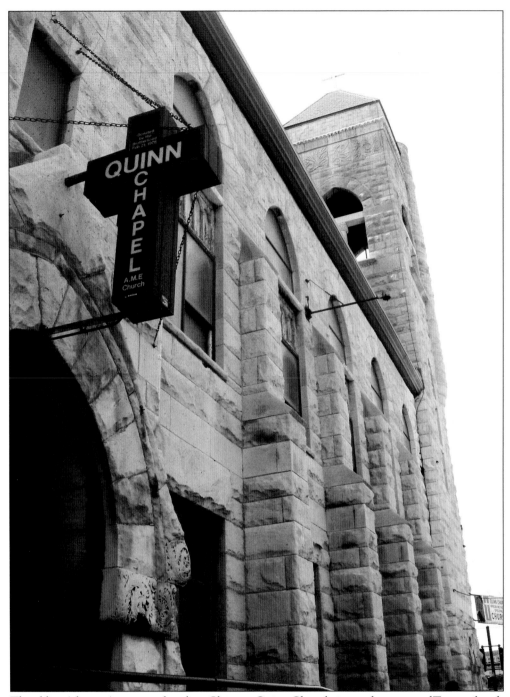

The oldest African American church in Chicago, Quinn Chapel, sits on the corner of Twenty-fourth Street and Wabash Avenue, an area once surrounded by black residents. These days, only those with middle-class and upper-middle-class incomes can afford to live in the area.

This image shows the cornerstone of Quinn Chapel. The historic church was the meeting place for black Chicago's leading political, business, and religious leaders in their fight for equal rights and justice. Although this building was constructed in the 1880s, the congregation was originally formed in 1847. In Christopher Reed's book *Black Chicago's First Century*, one old-timer talks with awe about the time, before the Civil War, when an eloquent, ardent, and fiercely intelligent ex-slave came to address them. His name was Frederick Douglass.

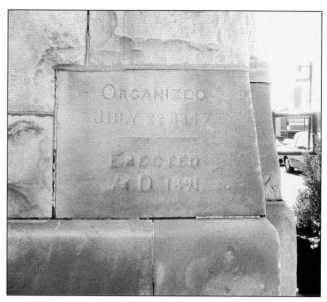

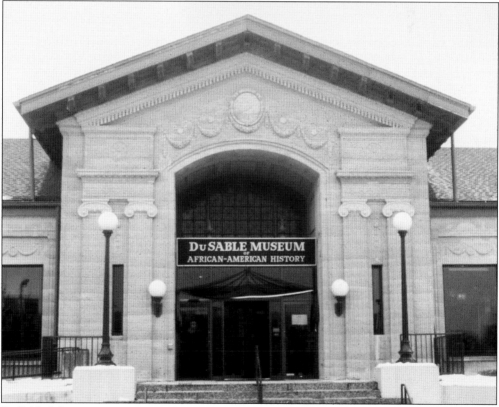

DuSable Museum is just one more institution that is part of the legacy of artist, teacher, and activist Margaret Burroughs. Started in the home she shared with her husband, Charles Burroughs, near Thirty-eighth and Michigan Avenue in the early 1960s, it is now located in Washington Park and headed by Dr. Carol Adams, who is currently spearheading a campaign to expand the museum so that it can display a greater portion of its historical artifacts.

Chicago has been the media capital of black America for a century or so. But, starting in the mid-1980s, Chicago became the home of another media phenomenon: Oprah Winfrey. Oprah is in the process of moving her headquarters from here to the West Coast, but her Harpo Studios still stands on Chicago's northwest side. Below is the former headquarters of the *Chicago Defender*.

Chicago has been the home of African American baseball since Andrew "Rube" Foster's days of building the Negro League in the 1920s, 1930s, and 1940s. But after Foster died, the legacy of his work can be seen in the success of black players in the major leagues. None is more loved than Ernie Banks. A monument to him stands here outside of Wrigley Field, the home of the Chicago Cubs.

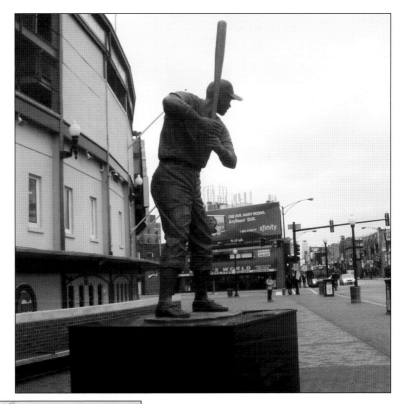

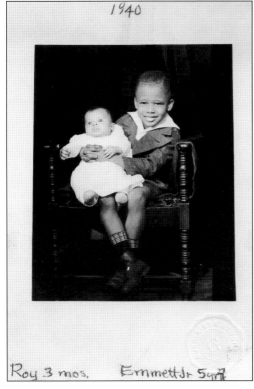

1940

Roy 3 mos. Emmett Jr. 5 yr

Emmett McBain holds his little brother in this 1940 photograph. He already had the look of the artist and adman he later became. In 1971, after he had already become one of America's first and few successful graphic designers, he started Burrell McBain Advertising with copywriter Tom Burrell. Although McBain left the agency after its initial quick growth—winning McDonald's and Coca-Cola as clients—Burrell Communications is still one of the world's largest black-owned agencies. (Emmett McBain.)

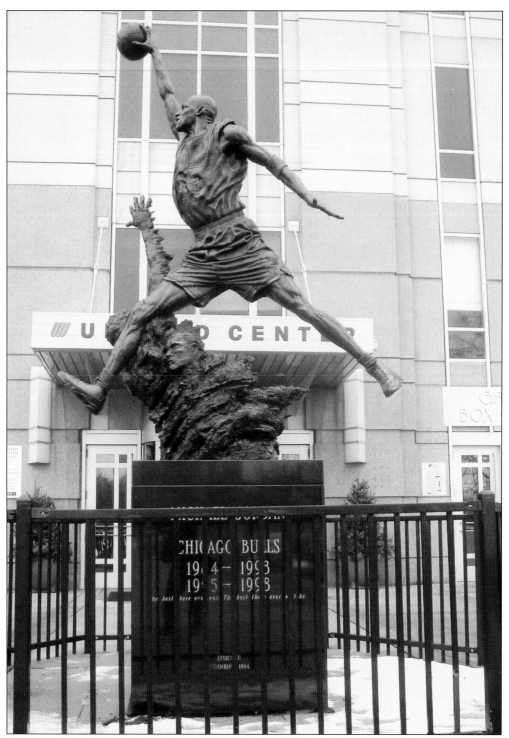

Some say United Center, the home of the Chicago Bulls, is as much the house that Michael Jordan built as Yankee Stadium can be called the house that Babe Ruth built. This statue shows that the Bulls management, at least, thinks there might be something to the claim.

This trumpeter was meant to herald a rebirth of the historic Forty-seventh Street in the Black Metropolis district. From the late 1920s through the early 1960s, this corner was the center of black Chicago culture. The famed Regal Theater was just a few hundred feet south. Unfortunately, although it still stands on the corner of Forty-seventh Street and King Drive, the other components of the revival are either expired or on life support. The Harold Washington Cultural Center (the corner of it is to the right of the sculpture) has sat greatly underutilized almost from the day it was built. The Great Recession of 2008 brought many of the gentrification and revitalization projects to a halt—at least until (if?) the economy picks up again.

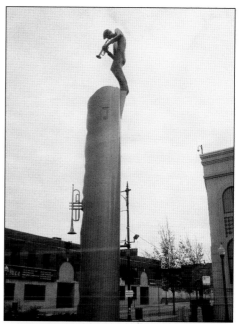

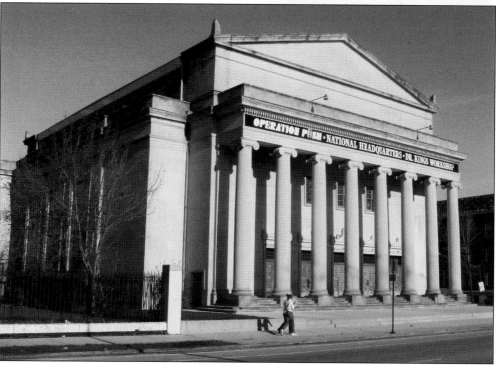

Jesse Louis Jackson came to Chicago as a graduate student but soon became an organizer for the Southern Christian Leadership Conference (SCLC), an organization headed by Dr. Martin Luther King Jr. Jackson's mission was to lead Operation Breadbasket, a campaign for economic empowerment. But in 1971, he quit and started his own organization with the same mission. He called it Operation PUSH. Its headquarters is on the corner of Fiftieth Street and Drexel Boulevard on Chicago's South Side.

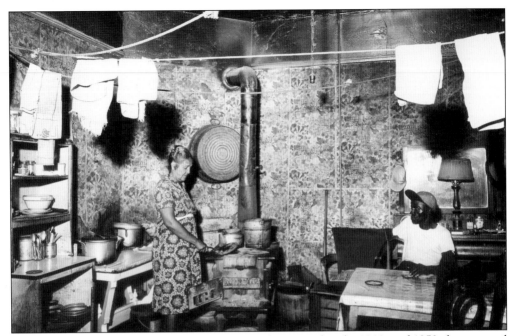

This is another image of the substandard housing that existed in the 1940s and 1950s for poor and working-class African Americans. This photograph is rare because it seems to show an interracial couple, which was theoretically legal in the north but extremely rare. In the South, it was a crime and an invitation to mayhem and death. (Chicago Housing Authority.)

In the early years of Robert Taylor Homes, there was an optimistic, positive inspirational attitude that is reflected in this photograph. But soon, neglected maintenance, poor management, indifferent policing, and gangs took their toll. Within 30 years of this event, the same Chicago Housing Authority (CHA) that built them with such glowing fanfare would be tearing them down. (Chicago Housing Authority.)

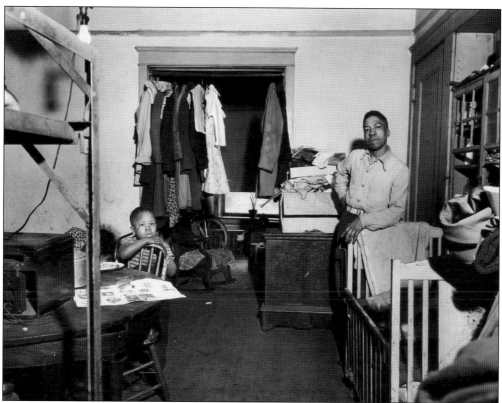

These images were part of the documentation of the need for a massive new housing project along the corridor between the railroad tracks and State Street and from Thirty-fifth to Fifty-seventh Streets. First Stateway Gardens was built in 1958, and then in 1962 came the mother of them all, Robert Taylor Homes. Taylor was the first African American head of the Chicago Housing Authority. (Both, Chicago Housing Authority.)

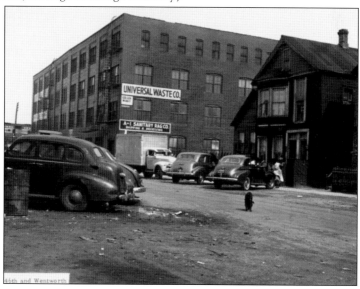

Erin Goseer Mitchell wrote a book about her life growing up in pre–civil rights Selma, Alabama, entitled *Born Colored*. (E.G. Mitchell.)

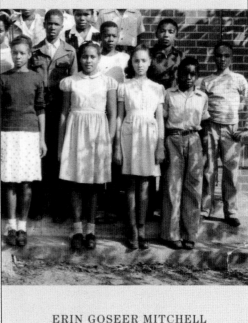

Her book cover was taken from a photograph of 12-year-old Erin (third from right and in the front row) and her eighth-grade class at Monitor School in Fitzgerald, Georgia, in 1947. (E.G. Mitchell.)

The school was one of hundreds of Rosenwald Schools. The initial funding came from Julius Rosenwald, who was the extraordinary Jewish American head of Chicago-based Sears, Roebuck and Co. His philanthropic efforts, especially on behalf of African Americans, were a rare example of Euro-Americans giving back to the group of Americans whose unpaid labor and unrequited oppression laid the economic foundation of the United States. Mitchell came to Chicago in 1956 and taught in Chicago schools for 38 years, retiring in 1994. (E.G. Mitchell.)

Alicia Lee's aunt Inez was a lively, creative, and athletic woman. A professional dancer at one point in her life, she was always active. Here, she poses (far right) with her bowling team in 1959. (Alicia Lee.)

Artist/adman Al Hawkins is pictured with SSCAC president Diane Dinkins Carr at a recent event.

This is a rare sight in Chicago during the 1950s—an integrated school. But likely by the mid-1960s, the school would become all black. (Lisa Biewel.)

Rickkay King talks with a security guard at the opening of a recent exhibit, The First Backyard, chronicling the first residents of Ida B. Wells housing project. King is a research and development fellow at the National Public Housing Museum, which mounted the exhibit as part of its buildup to the opening of the museum. The museum will be located in the area once occupied by Jane Adams's Hull House at the University of Illinois, Circle Campus, near the south and west sides.

Artist Toussaint Perkins points to himself in the photograph that appears on the opposite page. His father was the noted Chicago sculptor Marion Perkins.

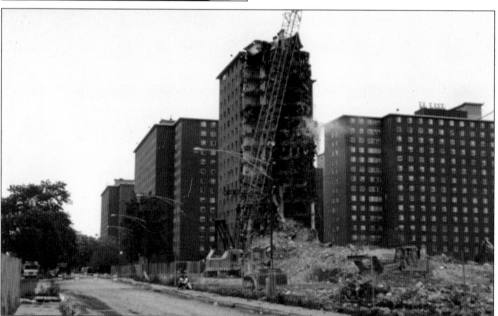

The last days of the notorious Robert Taylor Homes is captured here. The story of Chicago's public housing program is filled with villains and not many heroes. Robert Rochon Taylor, an African American administrator, was one of the heroes, who ironically had fought for many years to prevent the building of "high-rise concentration camps." However, the project was named for him after he died. (Chicago Housing Authority.)

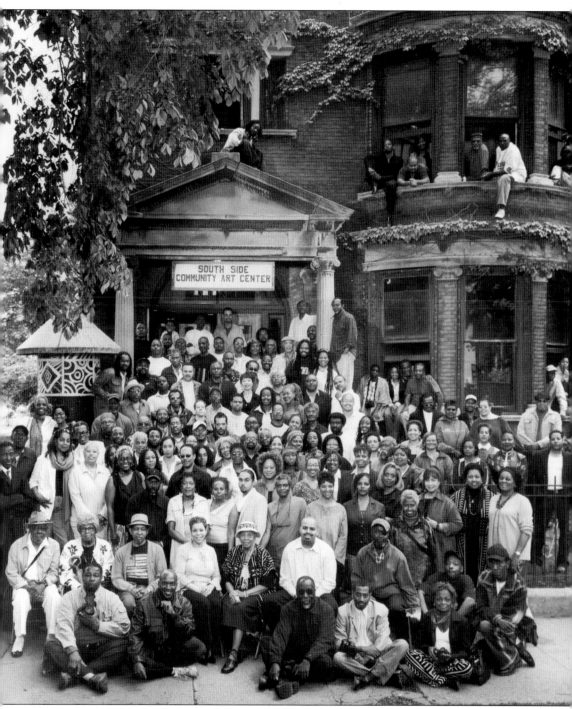

The art gang's all here. One morning, artist, gallery owner Jonathon Romain got many of the African American artists in Chicago to come to the South Side Community Art Center to pose for a photograph. Inspired by a famous image taken of many of America's jazz greats in Harlem in 1958, Romain thought this photograph would capture the spirit of this small but mighty institution and all who supported—and benefited from—its existence. (Jonathon Romain.).

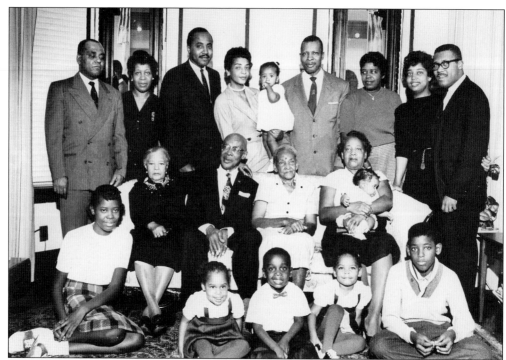

Emmett McBain (standing, far right) is pictured here in a family photograph taken in the mid-1950s. He was part of a South Side family and became one of the major figures in Chicago's graphic design and adverting industries, cofounding Burrell, McBain in 1971. It was the largest African American–owned advertising agency in America for decades. Below, a young McBain stands with one of his many award-winning designs. (Both, Emmett McBain.)

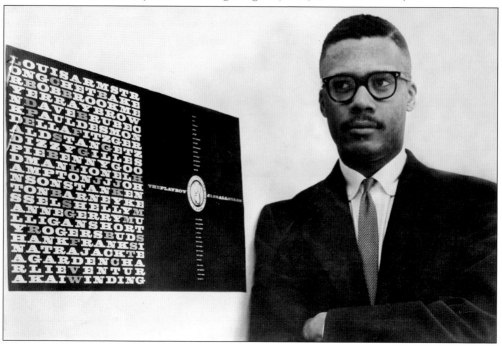

A woman heads south toward Thirty-seventh Street on Giles Avenue. This photograph could have been taken 55 years ago when the author lived here as a boy. But, beyond the frame of this photograph, it is a whole other world, with vacant lots and a small smattering of new single-family homes. The recent recession has caused many urban pioneers to rethink their journey. As an eight- or nine-year-old, the author remembers this as the route people took to Gus Courts candy store near the alley between Giles and Prairie Avenues near Thirty-seventh Street. Courts and his wife came to Chicago after they were nearly killed by the KKK in Belzoni, Mississippi, because they organized black folks to vote there in 1955.

The Wabash Avenue YMCA building still stands at 3763 South Wabash. It has long since been repurposed for its current mixed-use housing/community services function. When it was built in 1911, it quickly became an integral part of Chicago's black culture. It was one of the few public places African American travelers could stay—downtown hotels banned them. It became a hub of sports, cultural, social, and business activities. Carter G. Woodson founded his Association for the Study of Negro Life and History here in 1915. He went on to create Negro History Week (now Black History Month) in 1926.

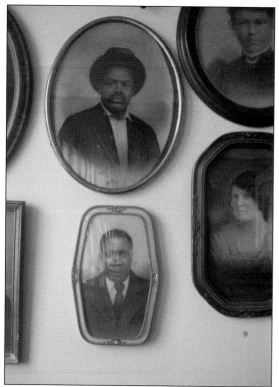

The photograph wall of the Bronzeville Visitor Information Center features classic framed photographs of African American Chicagoans going back at least a century. Soldiers, toddlers, entertainers, and everyday people (probably including at least one stockyard worker) are all dressed in their Sunday best. For many Euro Americans, it will be one of the few times they have seen historical photographs of black Americans as normal, well-groomed, and dignified people.

In 1911, this corner was fast becoming the newest, teeming center of black Chicago. As new black migrants fled the racist oppression of the South for the promise of work and a new life, they kept spreading farther and farther south, steadily lengthening the growing Black Belt. By 1921, this was known as the center of the Stroll, a bright-light district on State Street, and was a black business and nightlife district known for the hottest jazz in the world.

Four

WHITE FLIGHT

By the late 1940s, the exponentially growing African American population had stretched the proverbial Black Belt all the way to the South Boulevard to Sixty-third Street. New migrants had fled the South after losing much of their work to new cotton-picking machines and were flowing into Chicago's Illinois Central Twelfth Street station in numbers that dwarfed those of the first migration. They were taking over areas like Lawndale on the west side as Jews and Italians moved out to the newly built suburbs, sponsored by the discriminatory lending policies of the Federal Housing Administration and the US government.

In the foreword of his book, *Making the Second Ghetto: Race and Housing in Chicago 1940–1960* (1998 edition), Arnold R. Hirsch said, "The Federal Housing Administration (FHA), for example, routinely denied access to its benefits to African Americans in most instances, spurred disinvestment in our central cities, and fostered racial segmentation of metropolitan America by subsidizing white flight, [and it] is, by now, commonly recognized. Less well understood however, is the agency's affirmative support of segregation in its provision of housing for blacks with a Jim Crow context."

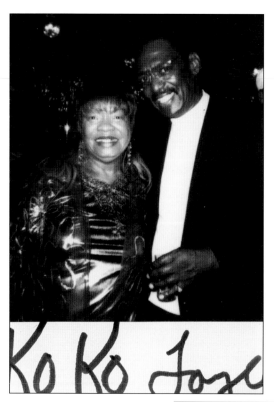

Danny Reed is a well-known local Chicago bluesman who came to Chicago the same way most African Americans did—he took the Illinois Central train, got off at the Roosevelt Road station, and went straight to work. Here, he is pictured with Koko Taylor. (Danny Reed.)

Reed, a proud Westsider, has played with many of America's leading entertainers. Here, he is with Dionne Warwick. He still leads his band occasionally but spends most of his time managing his real-estate holdings and studying African American history. These days Danny spends the second Sunday of each month at the meeting of the African American Genealogical and Historical Society of Chicago.

Every family should have an Uncle William and Aunt Audrey. William and Audrey Crissmond (pictured) had no children of their own, but they spent their lives contributing to the well-being of their extended family. William was a 40-year employee of the US Postal Service and was the older brother of the author's mother. Audrey worked most of her life as an administrative assistant in black-owned businesses. The Hopalong Thompsons were a big family, with eight boys and three girls. The photograph below was taken at the beginning of television merchandising. Hopalong Cassidy was the big star of Saturday morning television in the early 1950s. Every self-respecting kid had to get some gear. The cowpokes, from left to right, are Carl, Lowell, Steven, cousin Anthony (the hombre in the black hat), Paul, and Gregory at the bottom. Older siblings Freddie and Phyllis were already too hip to hopalong. Michael, Beverly, Benita, and Kerry weren't born yet. (Both, Steve and Felecia Thompson.)

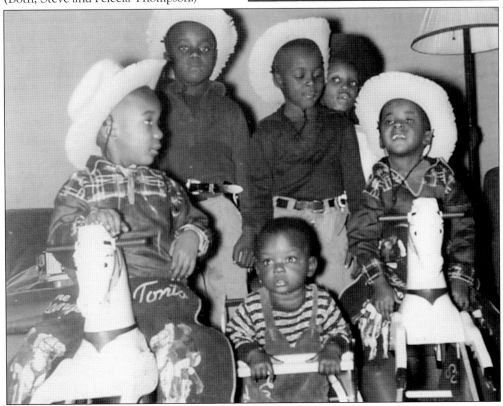

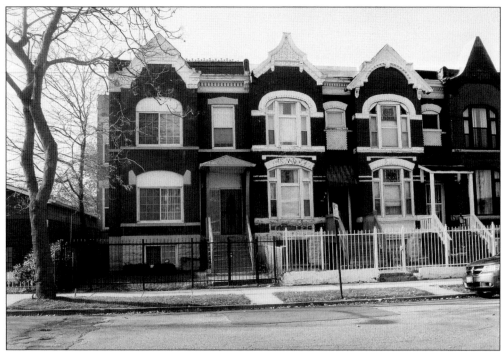

Above, these townhouses on Giles Avenue look almost the same as the author remembers them, when he grew up just a little south across the street in the 1950s. On closer inspection though, it looks like the one on the left has been a little modernized but maintains its relationship to the others. Below, these children on Giles, nearby Prairie, and Calumet Avenues were taken to this church building in the 1940s and 1950s by a group of young white missionaries. "I remember eating ice cream on the wooden benches next to the church on Sunday mornings," says Lowell Thompson.

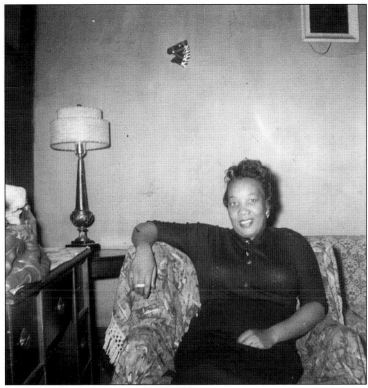

Above, Anna Mae Thompson, the author's mother, sits with her ever-present Lucky Strike cigarette at her home at 3625 Giles Avenue in the mid-1950s. Unlike many African Americans her age, she was actually born in Chicago in 1921. Below, a new home now sits at 3625 Giles Avenue, the address the Thompson family called home for 45 years from 1917 to 1962. (Above, Beverly Ann and Benita Lynn Thompson.)

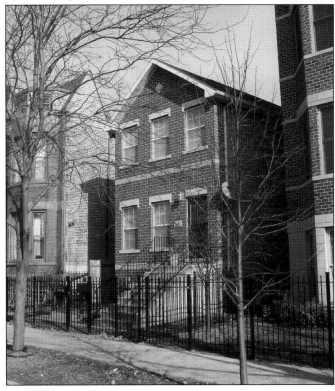

Above, André Guichard makes his exit from his Gallery Guichard and his entrance to the festivities of his Art di Gras in August 2010. The location and date of the annual art soiree are easy to remember, being just south of Thirty-fifth Street and King Drive, where the Bud Billiken Parade has started for over 80 years. Below, the man known as the father of Black History Month, Carter G. Woodson, was the second African American graduate of Harvard (after W.E.B. Dubois) when he came to Chicago. Here, in keeping with his lifelong goal of educating African Americans, he proposed that a week in February (the birth month of both Abraham Lincoln and Frederick Douglas) be declared Black History Week, which later became Black History Month. (Below, Library of Congress.)

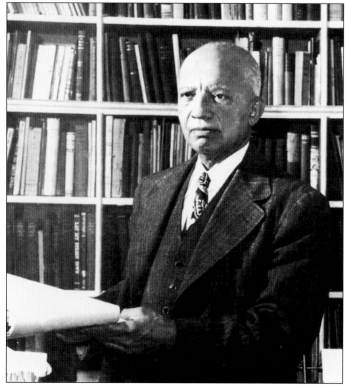

Above, Emmett Till was a 14-year-old Chicagoan when his mother, Mamie, sent him on the familiar African American journey "down South" to visit his relatives in Money, Mississippi, in 1955. As is now written in every history of pre–civil rights movement America, he never returned alive. When his mother brought his mangled, maimed, and mutilated body back and left the top of the casket open, it helped spark a demand for black equality, white morality, and justice that goes on to this day. Author Lowell Thompson said of the event, "I was a seven-year-old boy, living about three miles from the Till home when word came that Emmett was killed. I never knew him, but I'll never forget the horror." The photograph below shows some women of the Thompson clan and friends getting ready to make men drool. The author's Aunt Alberta is second from left. His mother, Anna Mae, is sixth from left. Aunt Martha Mae, the author's father's sister, is seventh from left. His mother's sister, Aunt Lucille, is on the far right. (Above, Library of Congress; below, Thompson family archives.)

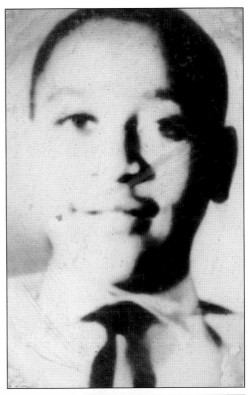

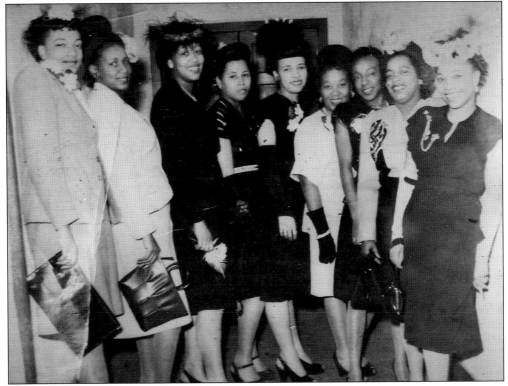

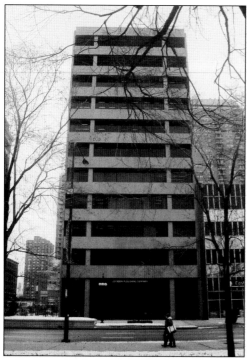

The office building on the left has the distinction of being the only one in downtown Chicago built by an African American–owned company and designed by an African American architect. Although the Johnson Publishing Company is in the process of relocating, *Ebony*, *Jet*, and various other enterprises by the company still have offices in the building. The architect was John Moutoussamy, whose daughter married tennis great Arthur Ashe.

John Harold Johnson was born in Arkansas City, Arkansas, in 1918. In 1933, he came to Chicago with his mother and stepfather. While working at Supreme Liberty Life Insurance Company in 1942, he got the idea for *Negro Digest*, his first publication. Johnson Publishing Company became the leading African American publisher in America. Combined with the older Chicago African American publication, *Chicago Defender*, it made Chicago the black media capital of the nation for most of the 20th century. (Both, Alice and Nelson Scott.)

Ida B. Wells is one of the most recognized names in Chicago history. For many, it only refers to a housing project that existed from 1941 until 2008. But for 50 years, before the project was built, the name Ida B. Wells referred to the fearless, anti-lynching crusading journalist, human-rights activist, and world-renowned lecturer. When she moved to Chicago in the early 1890s and married businessman/ publisher Ferdinand Barnett, she became one of our city's most famous and respected leaders, and thus the housing project was named after her. Unfortunately, like almost all of the public housing projects of the era, they had deteriorated into slums by the 1990s and were as bad or worse than the tenements they replaced. (Both, Library of Congress.)

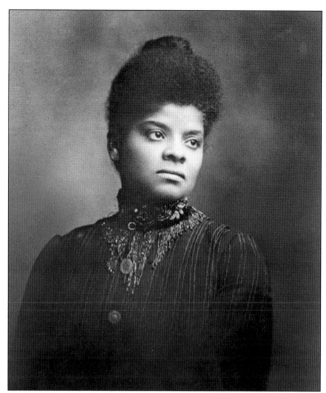

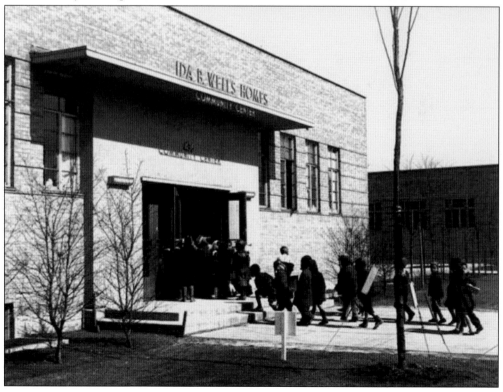

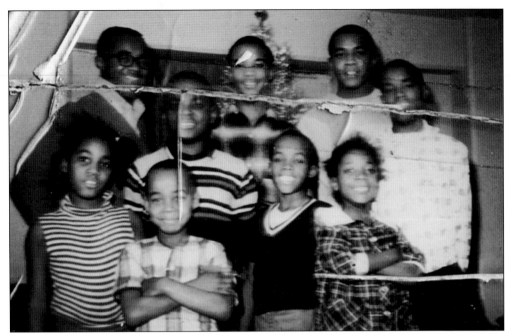

This badly damaged but precious photograph shows the Thompson children (minus the two oldest siblings, Frederick and Phyllis) after their move to the newly opening Robert Taylor Homes in 1962. From left to right, they are (first row) Beverly, Kerry, Michael, and Benita; (second row) Lowell, Gregory, Carl, Steven, and Paul. (Thompson family archives.)

In this photograph, famed sociologist St. Clair Drake lectures at Roosevelt University. By then, he had become well known in academia for his groundbreaking study of African American urban life. His research is in the Black Metropolis, which he coauthored with Horace Cayton while at the University of Chicago. Positive images of such accomplished black intellectuals, scholars, and scientists are more frequent today in "general media" but still grossly underrepresented compared to the daily onslaught of negative, frivolous, or purely pop, sports, and entertainment figures. But historically, notable Chicagoans like J.A. Rogers, the amazing autodidact writer/ historian; Euclid Taylor, the "Johnny Cochran" of black Chicago in the 1940s and 1950s; Silas Parnell, the man who helped thousands of African Americans get a college education; and many other real black heroes have been missing from contemporary media and history books. (Roosevelt University Archives.)

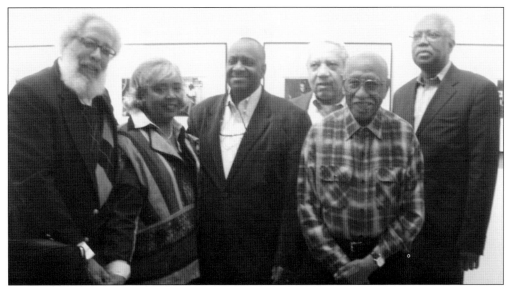

In this photograph, African American academics pose after a lecture by John Bracey (left) on St. Clair Drake at Roosevelt University in May 2011. Next to Bracey are Darlene Clark Hine, head of African American studies at Northwestern University; Robert Starks, professor at Northeastern Illinois University; Christopher Reed, professor emeritus of African American history at Roosevelt University; Timuel Black, civil rights and union activist, teacher, and professor emeritus; and Albert Bennett, professor, Roosevelt University.

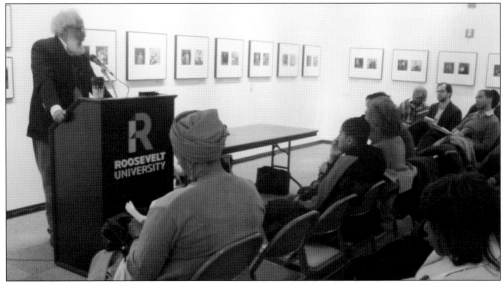

John Bracey, professor in the W.E.B. Du Bois Department of Afro-American Studies at the University of Massachusetts Amherst, came back to Chicago in May 2011 to give a lecture on St. Clair Drake, one of his professors when he was a student at Roosevelt University in the 1960s. When asked a question about the relationship between St. Clair Drake and Horace Cayton, coauthor of *Black Metropolis*, he said Cayton was the "streetwise" one, whose outgoing, boisterous personality made him the go-to guy for interviewing stockyard workers, pimps, prostitutes, policy kings, and their runners (and players). Drake was the more traditional scholarly type, whom Bracey guessed did most of the compiling and writing.

Veteran Chicago teacher, activist, and writer Timuel Black talks with Black Panther minister of information, Emory Douglas, at an exhibit of Douglas's artwork and graphics in Hyde Park. Douglas designed the *Black Panther Party* newspaper for decades. His cartoons featuring police officers as pigs have become iconic and widely imitated.

This image is the cover of one-time Chicago writer Richard Wright's nonfiction book *12 Million Black Voices*, published in 1941, one year after writing his breakthrough bestseller, *Native Son*, a novel based in Chicago and informed by his years of struggles after coming to the city from Mississippi, in 1927. Wright actually based the story of Bigger Thomas on a murder of a white woman by a black man that happened on the South Side not long after he left for New York. Margaret Walker, another writer who was still in Chicago wrote in her critical biography of Wright that she helped him by sending him newspaper clippings covering the murder and the trial. (Bronzeville Visitors Information Center.)

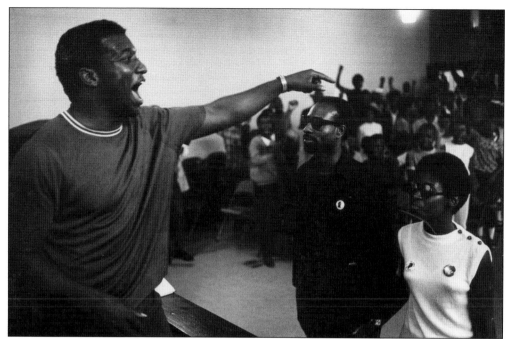

Above, Fred Hampton, the leader of Chicago's Black Panther Party. was a rising star and a fiery, forceful speaker on Chicago's west side. But he was murdered in a morning raid planned by state attorney Edward Hanrahan. It was later proven that it was a planned political assassination, part of a government plot to eliminate black leaders. (Photograph by Michael James)

The author's sister Beverly, father Fred Thompson, and aunt Mary Howard celebrate Beverly's latest accomplishment.

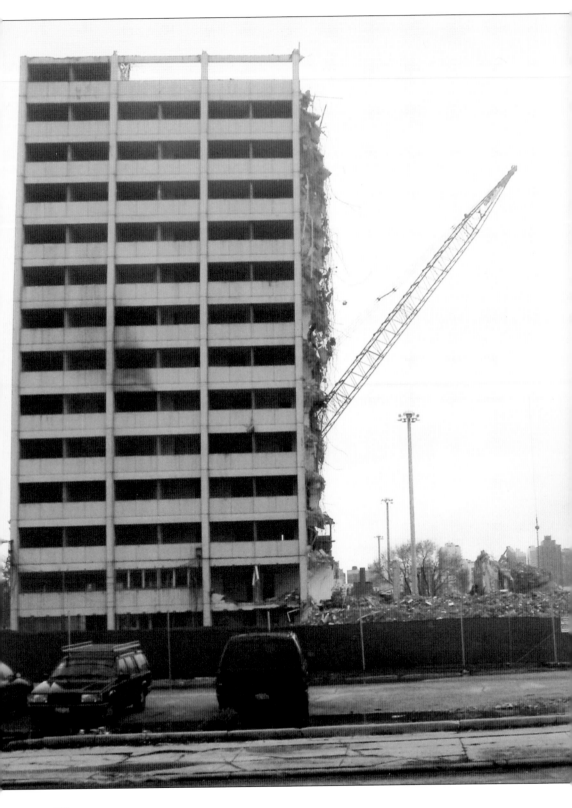

This photograph shows Cabrini's last stand. The final building of the inconveniently placed Cabrini Green housing project is half gone. When the project was built in the late 1940s and early 1950s, it was in an Italian American neighborhood near the north side. But, as with those neighborhoods on the South Side, it quickly turned into an all-black neighborhood when African Americans began to move in. For years, because of its proximity to Chicago's upscale shopping district, it was rumored to be the target of gentrification and scheming real-estate interests eager to turn its low-rent apartments into high-ticket condos and businesses. It took about 30 years, but by the early 2000s it was a done deal.

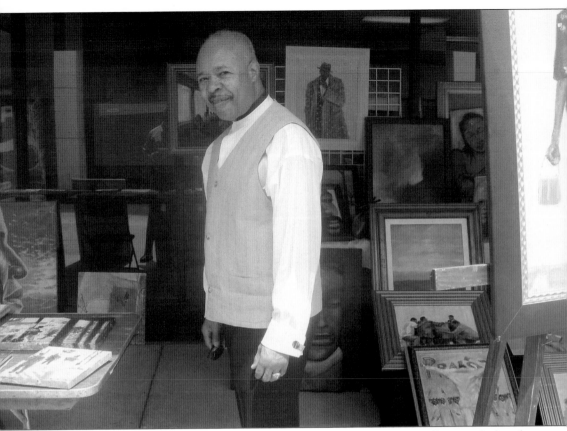

Daniel Texador Parker is one of Chicago's major African American art collectors. Cofounder of Diasporal Rhythms—an African American collectors group (along with Patric McCoy, Joan Crisler, and Carol Briggs), he published a beautiful coffee table book of his collection, *African Art: The Diaspora and Beyond*, in 2004.

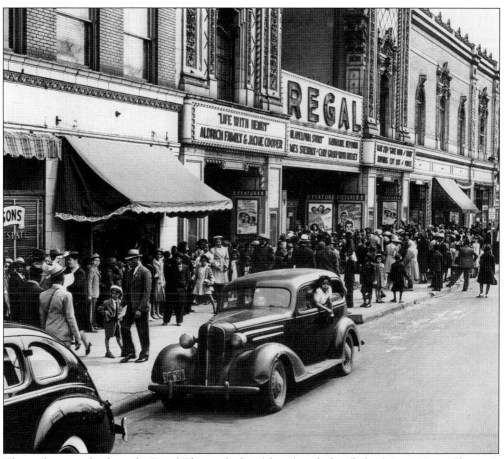

These photographs show the Regal Theater before (above) and after (below). In 1928, on Chicago's South Side, a rare event happened—a group of white businessmen opened a major development built specifically for African Americans. It was a speculative project and based on the burgeoning cultural enclave that would be later christened as, "the Black Metropolis," by African American sociologists, St. Clair Drake and Horace Cayton. Although the Apollo Theater in New York would in hindsight gather much more publicity and world renown, the Regal Theater was a much bigger and brighter by comparison. First, as mentioned, while the Regal was built from scratch for the African American market, the Apollo was converted from a theater originally built for whites only. Second, the Apollo did not become the "black" Apollo until eight years after the Regal was built. Lastly, the Regal was much more ornate and in the tradition of the Balaban and Katz showplaces such as the Chicago and the Uptown. (Above, Library of Congress.)

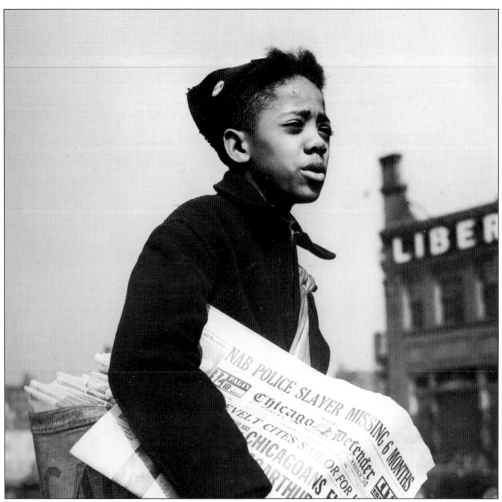

This is another great image from the WPA Farm Security Administration project, which put artists, photographers, writers, and other creative people to work documenting the culture during the Great Depression. This wonderful image of a *Chicago Defender* newsboy working the corner of Thirty-fifth Street and South Parkway (now King Drive) in 1941 would probably not exist (definitely not in the public domain) without such a program. It gave future great artists like Gordon Parks, Archibald Motley, Willard Motley, and Richard Wright critical experience, exposure, and income that allowed them to survive America's worst economic catastrophe. (Library of Congress.)

More than a few historians trace the history of the modern civil rights movement to the much older history of the Brotherhood of Sleeping Car Porters. Although its leadership is usually attributed to A. Philip Randolph of New York, Chicago's Milton Webster was his co-leader (and many say, the more beloved by its members). But even before the BSCP was officially formed in 1925, another Chicagoan, R.L. Mays, led his own predecessor group. According to the author, "Harry Mays, an old Giles Avenue friend, just recently gave me a heads up on his grandfather." (Library of Congress.)

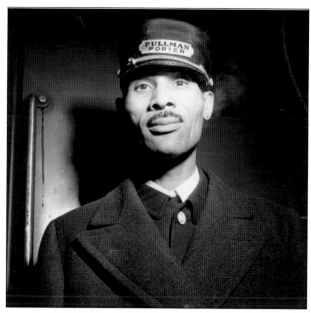

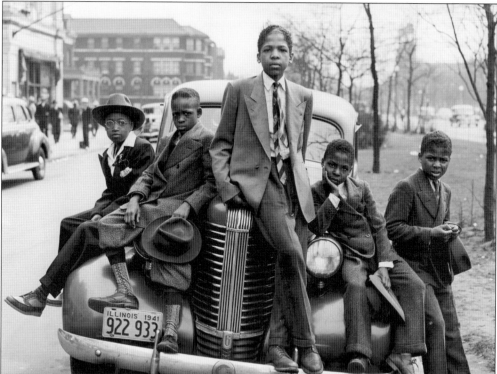

This photograph was taken on Easter Sunday in 1941 in Chicago. Many South Siders think it was taken on South Parkway, which is now King Drive. But it could just as easily been taken on Garfield Boulevard (Fifty-fifth Street). Both streets are wide and have grassy median strips. But whether Fifty-fifth Street or King Drive, this is a strikingly wonderful image. It would be interesting to find out what happened to these handsome and proud young men. Any ideas? (Photograph by Russell Lee; Library of Congress.)

Vacant lots like this cover a large part of Chicago's south and west sides. Federal and local government policies designed to keep African Americans segregated from the rest of society have made large swaths of formerly vibrant black neighborhoods uninhabitable until middle and upper class white and black urban pioneers took up the challenge, giving banks, government-invested money, and resources to support the areas.

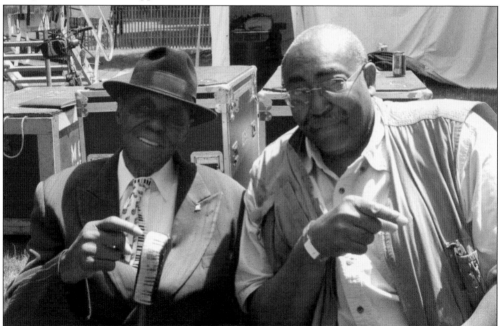

These two make up almost 150 years of Chicago blues. Pinetop Perkins, left, and Chicago Beau take a break at the Chicago Blues Fest. Perkins was one of the last links to the blues legends, like Howlin' Wolf, Muddy Waters, and Honeyboy Edwards. Ike Turner readily admitted he was taught by Pinetop. (Lincoln T. Beauchamp.)

Lu Palmer was one of black Chicago's most outspoken and respected journalists. He was one of the chief catalysts that spurred Harold Washington to run for mayor in 1981–1982. His home on the corner of Thirty-seventh Street and King Drive is an example of how the wealthy whites, who first built these homes, abandoned the neighborhood during the rapid expansion of the Black Belt. This palatial structure eventually became a multifamily tenement in the 1930s, 1940s, and 1950s.

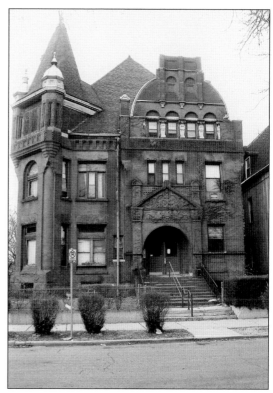

The famed anti-lynching and civil rights crusader Ida B. Wells lived at this house located in the 3600 block of King Drive. In 1893, she moved to Chicago, married businessman Ferdinand Barnett, and spent the rest of her life continuing to fight for the cause of equality and justice for all Americans.

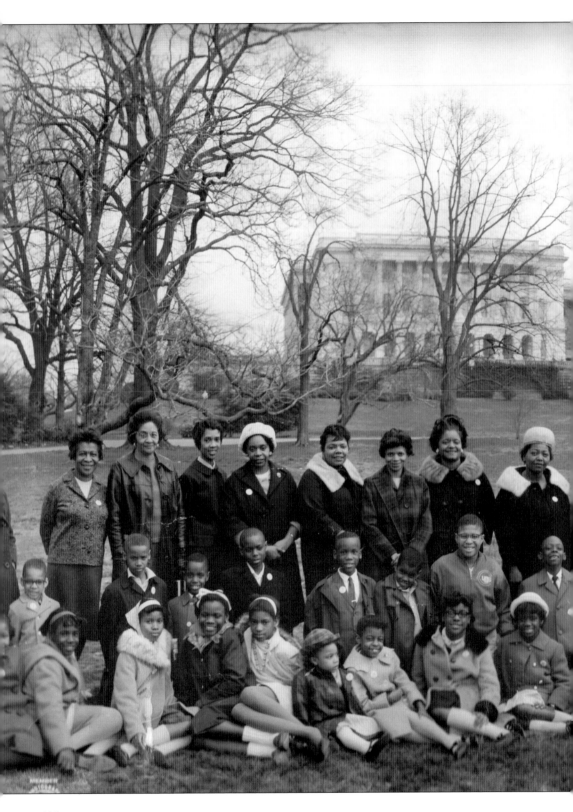

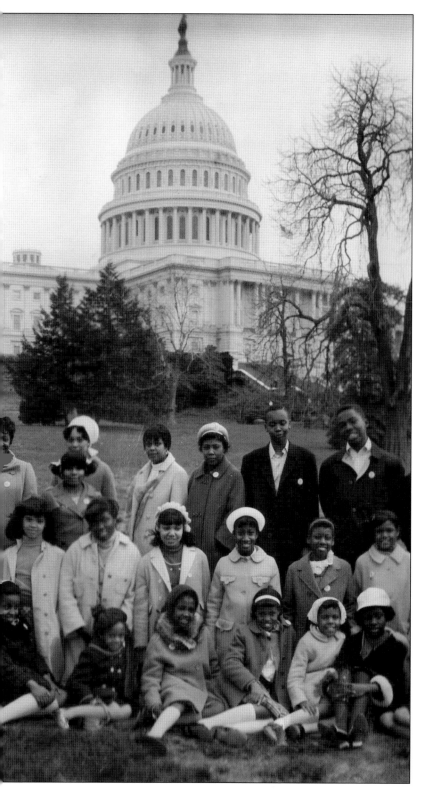

African American teachers have always been one of the most consistent links between the segregated, restricted world that many black Chicagoans grow up in and the larger, unlimited one. Here, Emmett McBain's mother, Beatrice McBain, is pictured with her Willard Elementary School class on a trip to Washington, DC, in the 1960s. Little did they suspect that by 2010, a Chicago South Side family, not unlike theirs, would actually be residing in the house not too far from the US Capitol behind them. Although the nation was in the midst of historic change, forced upon it in part by students in the South, no one could have predicted the result of their courage and commitment. (Emmett McBain.)

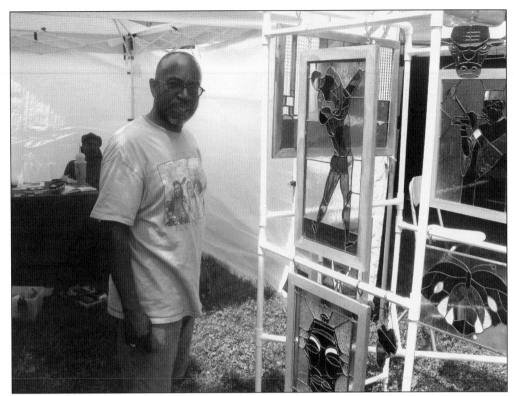

Ted Feaster retired from years working for the federal government, but he has always been an artist at heart. He grew up in Bronzeville when it was just called "the slums." He and his wife, Donna, have turned his talent for stained-glass creativity into a beautiful business.

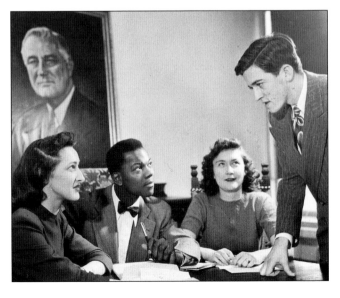

This seems to be a publicity photograph from Roosevelt University when it was still Roosevelt College. But it shows the radical nature of the school without saying a word. In the late 1940s and early 1950s, when this photograph was likely taken, African American men were being lynched for looking too hard at a white woman and were still fighting to serve in nonsegregated units of the Armed Forces. (Roosevelt University Archives.)

Lucy Parsons is a name that has been largely removed from African American history. But for over 40 years, she was arguably as famous as (and more radical than) Ida B. Wells. She was an African American and American Indian woman and was born in Texas in 1857. She married a Euro-American printer, publisher, labor leader, and anarchist, Albert R. Parsons, and moved to Chicago in 1873. Albert Parsons was hanged in 1887 after being convicted (probably wrongfully) for his role in the famous Haymarket bombing. Lucy Parsons spent the rest of her life as a formidable advocate for labor and human rights. Chicago police allegedly called her "more dangerous than a thousand rioters" because of her rhetorical and organizational skills. (Both, Library of Congress.)

Lucy Parsons Is Burned to Death in Chicag Husband Was Hanged After Haymarket Ri

Special to THE NEW YORK TIMES.

CHICAGO, March 7—Lucy Parsons, 83 years old, noted anarchist whose husband was hanged for his part in the Chicago Haymarket riot in 1886, was burned to death late today when a fire broke out in her frame residence at 3130 North Troy Street.

Severely injured in the blaze was George Markstall, 73, who tried without success to aid the aged woman. They were married several years ago, but the wife retained the name under which she had been publicized by radical elements for more than half a century. She was active as a writer on anarchism until a little more than a year ago, when she went almost completely blind.

Firemen who extinguished the flames carried Mrs. Parsons from the kitchen. Markstall was outside when he learned of the fire and ran in to aid his wife. He was found in a bedroom. His condition at the Belmont Hospital was described as critical.

To vindicate the memory of her husband, American labor leader and anarchist "martyr," Lucy E. Parsons wrote his biography, "Life of Albert R. Parsons, With a Brief History of the Labor Movement in America." After he was hanged in the Haymarket affair, she spent many years in the labor movement, preaching his ideals.

Parsons was born in Montgomery, Ala., in 1848, of pre-revolutionary New England stock. L an orphan at the age of 5, he w reared by a brother on the Te frontier. In 1868 he founded weekly Republican paper. Waco Sentinel, and in 1873 moved to Chicago where he work union, helped found a brand of Knights of Labor and became tive in the Socialist party. A lea in the railroad strikes of 1877. P sons became secretary of the Eig Hour League in 1879. In 1881 helped organize the American s tion of the Anarchist Internatio and in 1884 he founded the anar ist paper, The Alarm.

Parsons was one of the speak at the meeting in the Chic Haymarket on May 4, 1886, cal as a protest against the killing strikers at the McCormick H vester Works. A bomb was throw killing seven policemen.

After going into hiding Pars surrendered, was indicted for m der with seven other anarchi all immigrants, and on Nov. 1887, was hanged along w George Engel. A fifth man, L Lingg, a bomb-maker, commit suicide in his cell. Convinced the truth of Parsons' content that he and the three others w condemned not for murder but being anarchists and reform agi tors, Governor John P. Altg brought about the pardoning the three surviving men.

St. Clair Drake, coauthor (with Horace Cayton) of the well-known sociology study *Black Metropolis*, was also a professor at Roosevelt University in the 1950s. (Roosevelt University Archives.)

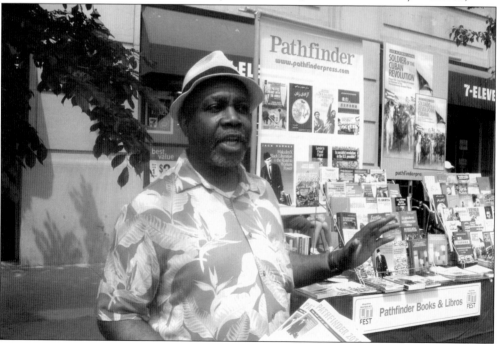

Pictured here is Leroy Watson at the Printers Row LitFest in 2011. He is a member of the Socialist Workers Party. Like Lucy Parsons, he represents a long tradition of African Americans who have questioned and actively challenged American structural inequality, racism, and injustice.

Omar Hamadi (born Oscar Johnson), who ran the newsstand at Seventy-first and Paxton for years, is a street poet and aspiring jazz drummer. His family came to Chicago from Como, Mississippi, in 1953, the year he was born.

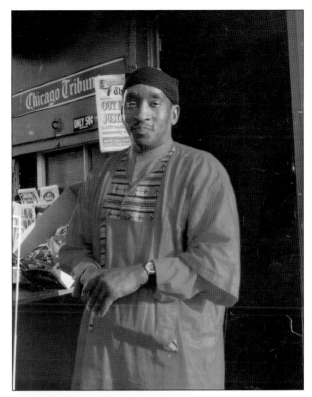

Future mayor Harold Washington (second from left) practices his voluminous vocabulary on a group of potential Chicago voters as a student at Roosevelt University in the late 1940s. The guy on the right does not seem to be totally sold. (Roosevelt University Archives.)

Located on 2120 S. Michigan Avenue, this building is one of the most important addresses in music. It was the home of Chess Records from 1957 to 1967. Many of the musicians who recorded here became legends in pop music, blues, jazz, and rock and roll. Bo Diddley claimed to have created the first rock-and-roll records here and so did Chuck Berry. The address is now the home of the Willie Dixon Blues Heaven Foundation. Although Leonard and Phil Chess ran the company, it is said that Willie Dixon, a heavyset African American ex-boxer, musician, songwriter, and producer, ran the sessions on almost every blues recording.

Five

THE LAST WORD?

What is the bottom line? The experiences of African Americans in Chicago echo the history of America. Wealthy whites brought them here to do the lowliest, dirtiest, and most dangerous work. And when they no longer needed them, they tried to ignore them to death. One of Thomas Jefferson's wrongest predictions (among many) was that African Americans would gradually die off, unable to compete mentally or physically with whites.

The American tradition of the demonization and marginalization of African Americans is alive and well in the second decade of the third millennium here in Chi-Town. The latest headlines of the *Tribune, Sun-Times,* and *RedEye* chronicle the crimes of a relative handful of us while ignoring the continuation of historically unequal policing policies, labor discrimination, and a pitiful education system that turns potential healthy taxpaying citizens disproportionately into criminals or wards of the state.

The black population here has dropped almost 20 percent over the last decade. The housing projects, built in the late 1940s, 1950s, and 1960s, contained the overflow from the great migrations and are almost totally gone. The valuable close-to-the-Loop land that they once occupied is empty. The only thing keeping the gold rush in check is the still miserable housing market—the vestige of the Great Recession in 2008.

With all the problems that black Chicago had, what is most amazing is how so many of them achieved so much in spite of it. Indeed, an African American—from Chicago, no less—now occupies the Oval Office. There have been countless studies, papers written, and conferences assembled to study the black problem. From Gunnar Myrdal's *An American Dilemma,* Nicholas Lemann's *The Promised Land,* to Arnold Hirsh's *Making of the Second Ghetto,* white sociologists, historians, and scholars of every stripe have pondered the phenomenon of black poverty, gangs, and pathology. Even Cayton and Drakes's *Black Metropolis* is largely a report on our problems.

But hardly any acknowledge the almost unbelievable accomplishments and people that have come out of and still live in Chicago. Hopefully, this book is a start.

The Harold Washington Cultural Center was opened in 2004 as part of an attempt to revitalize the area that once was known as the center of black Chicago from the late 1920s until the mid-1960s. It was located at Forty-seventh Street and South Parkway (now King Drive). In fact, the center is in the exact spot where the South Center office and shopping complex once stood. Next-door to it was the Regal Theater, and next to the Regal was the famed Savoy Ballroom.

Directly across from the Chicago Bee Branch of the Chicago Public Library and Thirty-sixth Place and State Street is nothing. This is the empty site of what was once one of Chicago's first high-rise housing projects, Stateway Gardens, built in the 1950s. The thousands of families that once lived here have been forced to move much farther south. According to the recently released US Census figures, many moved back to their pre-migration origins in Mississippi, Alabama, and Georgia. In the distance is the US Cellular Field, home of the White Sox.

There is a history lesson in this mural, and this colorful image on the side of the Donnelly Community Center is located on South Michigan Avenue. It was one of the creative collaborations between Mitchell Caton and Calvin Jones. Below, a photograph of Calvin Jones sits on an artist's easel at his memorial service at the South Side Community Art Center, where many exhibitions of his work were held over the years. He died in Arcata, California, in 2010.

If one person can be given credit (or blame) for creating the community mural movement in America, it is the person in this photograph. His name is William Walker, and usually his name comes out first when anyone mentions the Wall of Respect created in 1967 on the corner of Forty-third Street and Langley Avenue. WOR is considered by many the first grass-roots community-initiated mural in America. They say that Walker, a CTA bus driver at the time, decided that art could help counteract the effects of governmental and corporate neglect and gang graffiti in the South Side neighborhood, which was once a part of the historic but deteriorating Black Metropolis. Walker and AfriCobra artists gave it a try in the summer of 1967.

Walter Massey (left) chats with J. Ernest Wilkins Jr. at a 2007 event at the University of Chicago. Massey, a prominent physicist, is the former director of Argonne National Laboratory. Wilkins, a mathematician and physicist, was said to be the youngest person accepted at the University of Chicago (age 13). They both represent the intellectual achievements of many African Americans in Chicago who have historically been made invisible in mainstream media. (Photograph by Dan Dry.)

The once teeming site of Ida B. Wells Housing Project sits empty after being torn down in the mid-2000s. Named after the famed anti-lynching and civil rights leader Ida B. Wells (who actually once lived only a few blocks north), the project had been home to low-income but aspiring African Americans since it was built in 1941.

Subway serenades are nothing new to Chicagoans taking the Redline. Here, at the Jackson hub, three veteran songsters entertain with a masterful mixture of oldies and goodies. Seldom has this much talent been given so freely.

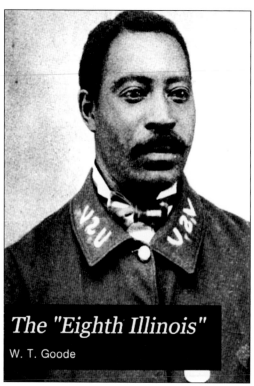

The "Eighth Illinois"

W. T. Goode

William T. Goode (left) was a volunteer in the Eighth Regiment Armory. That is when he saw action in Panama and Cuba. Amazingly, when he got back, he wrote a book, *The Eighth Illinois*, about his experiences. For anybody to write a book and get it published even now is a monumental task. But for an African American man in the early 1900s, to do so was miraculous. (Chicago Public Library Special Collections.)

The Chicago Bee Building on State Street was constructed by African American entrepreneur Anthony Overton to house his newspaper, the *Chicago Bee*, a conservative competitor to the more sensational *Chicago Defender*. The bottom floor was converted into a Chicago Public Library branch.

Turtel Onli is an artist/ teacher who has put on the Black Age of Comics confab for years. Onli has been a longtime advocate and promoter for black comics and comic book artists, but he is also an artist/ designer, teacher, and art therapist, with a talent for self-promotion. Witness him "unseating" the great Harold Washington's city hall chair in the 1980s after winning a contest. (Turtel Onli.)

Hundreds of African American comic book artists and fans come out every year to see and meet the latest, greatest comic book creations and creators at Onli's Black Age of Comics conventions. This one was held at Chicago's Kenwood High School in the Hyde Park/Kenwood community. The Black Age of Comics conventions help young, talented artists and their parents see that African Americans are making their mark (pun intended) in yet another industry that has been historically less than full color.

A colorful Chicago character, Patrick McCoy is one of Chicago's leading collectors of African American art and the cofounders of Diasporal Rhythms, an African American collector's association. McCoy recently retired from a career as an EPA scientist.

Ann "Afa" Faust is a retired special-education teacher and prolific and beloved artist. She also collects the work of other African American artists.

And last, but not least, pictured here is the Obama family. Although we all know that Barack Obama's father was from Kenya and his mother from Kansas, he himself has been a Chicagoan for many years. But his real street credential has to come from his better half, Michelle Obama. She grew up on Chicago's South Side with her father, mother, and older brother. Her family, like most black Chicagoans, goes much farther South and all the way to South Carolina, where her great-great-grandfather was a slave. They still have their home in Chicago, in the Hyde Park/Kenwood community, which is not far from Operation PUSH. (The White House.)

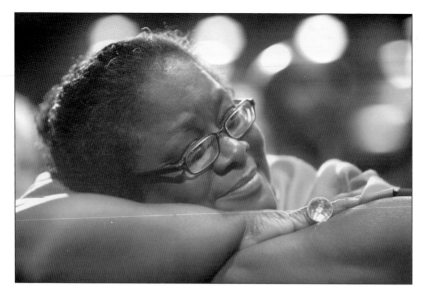

Pictured here is an Obama admirer, who is listening to him speak during a recent trip back to Chicago. (The White House.)

This painting, titled "Dreams Can Come True," was completed by the author on June 21, 2008, about a week before Barack Obama beat Hillary Clinton for the Democratic nomination for president. It was unveiled at the 2008 Lake Meadows Art Fair. Many people do not at first see the four large profiles of "dreamers" that led to Obama's presidency. (Painting by the author.)

SOURCES

Without the sources below, it would have been impossible for me to write and compile the visual materials for *African Americans in Chicago*. But, as hard as I tried, I could only scratch the surface of story as deep and wide as that of black Chicago in a 128-page book. For those of you who want to dig deeper, I hope this list helps get you started. Most are books, but some are websites, blogs, archives, etc., that contain credible, well-researched information and images, much of which would otherwise be inaccessible to all but those funded by major institutions. Thank God for the Chicago Public Library . . . and for the Internet, Google, Bing, Yahoo!, and others. They all have "democratized" knowledge beyond anything generations before us could ever have imagined.

Albertson, Chris. *Stomp Off* (stomp-off.blogspot.com)

Andreas, A.T. *The History of Chicago*

Baldwin, Davarian. *Chicago's New Negroes*

Chicago's Metro Almanac

Danker, Ulrich, and Jane Meredith. *Early Chicago*

Encyclopedia of Chicago Online

Green, Adam. *Selling the Race*

Hirsch, Arnold R. *The Making of the Second Ghetto*

Lemann, Nicholas. *The Promised Land*

Library of Congress, Pictorial Archives

Linton, Cynthia. *Ethnic Coalition Handbook*

Kogan, Herman, and Lloyd Wendt. *Big Bill of Chicago*

Miller, John Chester. *Wolf By The Ears: Thomas Jefferson and Slavery*

National Archives at Chicago

Pattillo, Mary. *Black on the Block*

Pruter, Robert. *Chicago Soul*

Reed, Christopher Robert. *Black Chicago's First Century*

Reed, Christopher Robert. *The Rise of Chicago's Black Metropolis, 1920–1929*

Rosen, Louis. *The South Side*

Stange, Maran. *Bronzeville*

Thompson, Nathan. *Kings: The True Story of Chicago's Policy Kings and Numbers Racketeers*

Travis, Dempsey. *An Autobiography of Black Chicago*

Tuttle, William Jr. *Race Riot*

The White House

Wilkerson, Isobale. *The Warmth of Other Suns*

Wright, Richard. *12 Million Black Voices*

www.mrdankelly.com

DISCOVER THOUSANDS OF LOCAL HISTORY BOOKS
FEATURING MILLIONS OF VINTAGE IMAGES

Arcadia Publishing, the leading local history publisher in the United States, is committed to making history accessible and meaningful through publishing books that celebrate and preserve the heritage of America's people and places.

Find more books like this at
www.arcadiapublishing.com

Search for your hometown history, your old stomping grounds, and even your favorite sports team.